MAKE GREAT PHOTOS

A Friendly Guide for Improving Your Photographs

ALAN HESS

MAKE GREAT PHOTOS
A Friendly Guide for Improving Your Photographs

Alan Hess
www.alanhessphotography.com

Project editor: Maggie Yates
Project manager: Lisa Brazieal
Marketing manager: Mercedes Murray
Copyeditor: Maggie Yates
Proofreader: Patricia J. Pane
Layout and type: Aren Straiger
Cover design: Dave Clayton
Indexer: Maggie Yates

ISBN: 978-1-68198-391-2
1st Edition (1st printing, November 2018)
© 2019 Alan Hess

Rocky Nook Inc.
1010 B Street, Suite 350
San Rafael, CA 94901
USA

www.rockynook.com

Distributed in the U.S. by Ingram Publisher Services
Distributed in the UK and Europe by Publishers Group UK

Library of Congress Control Number: 2018952209

Dedicated to Nadra Farina-Hess

Acknowledgements

This is my sixteenth book, and the one thing I can say that is true about all of them is that I could not do this alone. I don't live in a vacuum and I certainly don't write in a vacuum. I have a lot of support from my family, my friends, and the team at Rocky Nook. This is the place where I get to give some thanks and credit to those who supported me as I worked on this book.

I could not write these books without the team at Rocky Nook. As an author, working with this team is a treat because they really do want to produce the best photography books. Thank you Scott, Ted, Maggie, Mercedes, Lisa, Aren, and Pat. I could not have done this without your support and patience (lots and lots of patience).

Getting to work with friends is a huge plus and with this book, I got to work with one of my best buds. The talented Dave Clayton worked on the overall design and look of this book, and I could not be more pleased with how it all turned out. As a bonus, I got to visit with Dave and his awesome family in the summer of 2017. The young soccer player on the back cover (and featured in the book) is Dave's talented young daughter, Elise. It was an honor and privilege to photograph her dominating at the soccer match.

There are some friends that keep you sane. A few years ago I met Glyn Dewis and he, along with Dave Clayton, quickly became that type of friend. We don't get to see each in person very often, but that doesn't seem to matter. These guys keep me centered, allowing me to rant and rave, and always have my back. I appreciate that now more than ever.

One of the best things about the photography community is the great conversations that we have discussing art, photography, design, life, family, cameras, and just about everything under the sun. I want to thank you all for enriching my life with your presence and your knowledge: Joe McNally, Mark Heaps, Jesus Ramirez, Moose Peterson, Aaron Blaise, Scott Diussa, Brad Moore, Drew Gurian, Tim Wallace, Brad Mathews, Charles Jischke, Rick Sammon, Larry Becker, Colin Smith, Rob Sylvan, Kaylee Greer, Sam Haddix, Zack Arias, Julieanne Kost, Dave Black, Kathy Scibetta (Waite), Corey Barker, Frank Doorhof, Dan Knighton, Glyn Dewis, Dave Clayton, Mickey Strand, Mike Savoia, Alex Mathews, Donald Page, and Rob Foldy.

A local camera store is a blessing. It's a place to go not only to get the latest gear, but to learn and grow as a photographer. I am blessed with a great local camera store, Nelson Photo Supplies, which supports the San Diego photography community.

A huge thanks to all the people who allowed me to use their images in this book. I am trying to make sure I got you all covered here, but if I missed anyone, I am truly sorry. In no particular order: Brandon, Jessica, Elise, Elina, Jennifer, Sam, Nicole, Mia, Glenn, Mark, Zach, Oscar, Chris, Shawn, Sierra, Kasey, Lyle, Cody, Wendy, Conner, Armando, Kiona, Laura, Dave, Kristy, Krista, C-Sharp, Cameron, Chance, Andy, and Bill.

Finally, I owe it all to my loving and supportive wife. She deals with the ups and downs that come with writing a book (or sixteen) and does it with a smile and a laugh. I am a very lucky man.

CONTENTS

Introduction

I don't remember that moment when I first picked up a camera, but in college I needed to take an arts elective and picked an intro to photography class. It wasn't because I was a good photographer (I wasn't), but more due to my complete lack of traditional artistic ability. I can't draw or sculpt, and the only painting I could do was on a wall with a roller. But I needed to take an art class, and photography sounded like something I could do. That class didn't change my life, at least not then, but it did start a relationship with photography that has grown over the years from a slight infatuation to a full-on love affair. During that time, I have grown from a college kid with an old, all-manual Pentax film camera to a professional photographer using some of the most advanced digital cameras available. During that time, I have taken a lot of photos, some of which are actually pretty good. I have also taken some really bad photos—lots and lots of really bad photos. It took time and experience to figure out what worked, and what didn't. My goal here is for you to take advantage of all those bad photos I took, so you can learn from my mistakes and cut down the time it takes to understand how to make better photos.

As a photographer, I get to decide quite a bit about what and how my camera captures the scene. I get to decide what focal length, aperture, and shutter speed to use. When you go out to "take" a photo, you are letting the camera or the scene dictate how it is captured; when you "make" a photograph, you get to decide on the setting as an active creator.

The first part of the book introduces basic photography topics:

- Chapter 1 gets us, the author and the reader, on the same page. This chapter is filled with examples of the topics we will be covering in the book.

- Chapter 2 deals with light, the basis of all photography. This chapter covers why light is important, the basics of the exposure modes, and how sensitive your camera is to light.

- Chapter 3 covers focus, aperture, and depth of field, along with how shutter speed controls the look of action shots.

- Chapter 4 covers the basics of composition and what you should look for when composing your images. This chapter also covers the lens, focal length, and some of the first choices you have to make when deciding how to capture the scene in front of your camera.

The second part of the book is more subject-specific:

- Chapter 5 covers travel photography and related subjects like landscapes, people, and buildings.

- Chapter 6 covers action and sports, including specifics on soccer, baseball, surfing, and how to use manual exposure mode to make consistent images. Each of these chapters expounds on some of the critical choices that you will have to make and gives the settings that I think are a great starting point.

- Chapter 7 is about event photography. It covers some of my favorite subjects, like conferences and concerts. At the end of the subject-specific chapters is a little extra section with some more advanced concepts, like using a slightly slower shutter speed in concert photography to show some motion.

- Chapter 8 is all about photographing people, both with natural light and when using a flash. Each chapter also has a section of assignments where you can try techniques that can make a big difference in your images.

- Chapter 9 gives an overview of some post-processing edits that can make your photos stand out. This is not a post-production or image-editing book, but there are a few quick edits you can do (on your smartphone) that can improve your photos.

You don't have to read this book in order, but I believe it helps to read the first sections before you move on the subject-specific chapters. A quick refresher on the exposure modes and metering modes will make the terms and directions in the later chapters more easily understood. At the end of each chapter there is a small section of practice tasks that you can try at home.

A final note: If you have any questions, or if you want to share a photo with me, you can always email me at alan@alanhessphotography.com.

Thanks for picking up this book! Go grab your camera and let's get started!

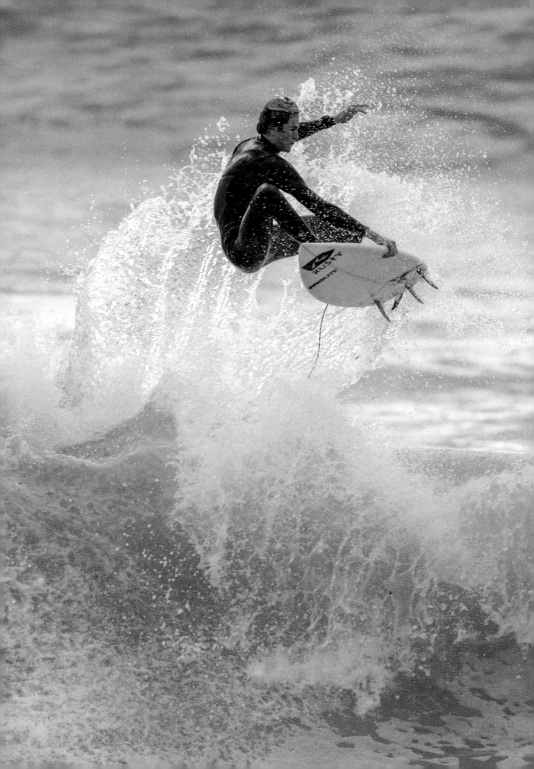

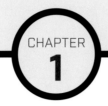

WHAT MAKES A GREAT PHOTO

Anyone can take a photograph. Photography is the great equalizer in art. I can't sculpt or paint, and if you saw my drawings, you would think a 3-year-old was let loose with a set of markers, but I can look through a viewfinder and press a button. There is no physical skill required to take a good photo. So what makes a good photo good, or what makes a one photo better than another? What makes you stop and really look at an image?

It could be the subject, the way the subject is lit, or where the subject in the frame. But more than likely, it is a combination of all these things. The good news is that with some knowledge and practice, you can take great photos.

The first step toward improving your photography is to look at the things that make a good photograph. This chapter is all about setting up a common language that we can all follow. It's no good if I tell you to freeze the action or look for the soft light when you don't know exactly what I mean. This chapter is filled with examples of the specific ideas we will be discussing in the rest of the book. These are real-life examples meant to show you a specific technique. These are not heavily staged or processed images; instead, they are photos of a variety of subjects taken with different types of gear to show you what to look for.

Proper Exposure

A properly exposed image will have the right amount of light—meaning the main subject will not appear too bright or too dark. Three things control the amount of light that is allowed to reach the sensor: shutter speed, aperture, and ISO. Shutter speed controls the amount of time the sensor is exposed to light. The aperture is the size of the opening in the lens the light passes through. The ISO controls how sensitive the sensor is to light. The higher the ISO, the less light is needed to create a proper exposure. These are the only controls that affect the exposure of your image. Too much means the image will be overexposed (all the detail in the light areas will be lost, and will appear pure white). Too little light means the image will be underexposed (all the detail in the dark areas will be lost, and will appear pure black). Chapter 2 goes into how to get a proper exposure in much more detail, but for now, let's just look at a few examples (**Figures 1.1–1.4**).

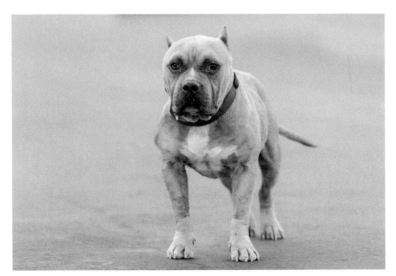

Figure 1.1 This cute dog was photographed in the even light of a very cloudy day in the parking lot of the rescue organization. The exposure was pretty simple to get right since there were no real bright spots or dark areas.

1/640 second; f/3.2; ISO 800; 180mm

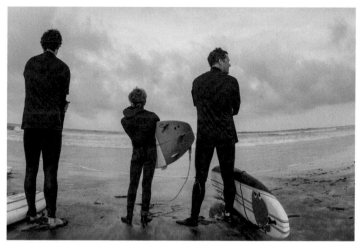

Figure 1.2 The cloud cover made it pretty simple to get a proper exposure of these three as they got ready to go surfing. You can see the details in both the bright and dark areas of the frame, including the wetsuits.

1/800 second; f/5.0; ISO 500; 20mm

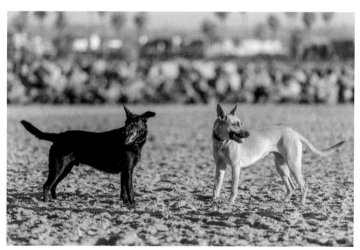

Figure 1.3 This image shows that it can be more difficult to get a proper exposure in direct sunlight, especially with subjects that are both very light and very dark. You can still see the detail in the bright area, but there is some loss of detail in the dark fur.

1/2000 second, f/3.5; ISO 100; 200mm

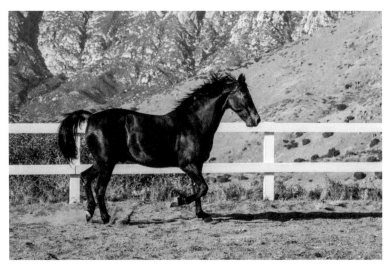

Figure 1.4 Photographing a dark horse against a light fence makes it difficult to expose to maintain the detail in both parts of the subject. I waited until the horse turned so that the sun was coming in across its body to highlight the detail.

1/1000 second; f/5.6; ISO 400; 85mm

Soft Light and Hard Light

Photography is all about light and how that light shows the subject that we are capturing. Two of the most widely used terms to describe the quality of the available light are soft light and hard light. So what makes some light hard and other light soft? The simple answer is that hard light is generally from a small light source and soft light is generally from a big light source. The easiest way to see if light is hard or soft is to look at the shadows created by the light. Hard light will cause sharp-edged shadows, while soft light creates a much softer transition into the shadows. Neither light is good or bad—both kinds of light can be used to create good photos—but you need to understand the difference between them so you can use them to your advantage. Traditionally, soft light has been used to create flattering, "pretty" portraits, while hard light has been used to create more stark portraits. You can see examples of soft light and hard light in **Figures 1.5–1.8**. All the different aspects of light are covered in chapter 2.

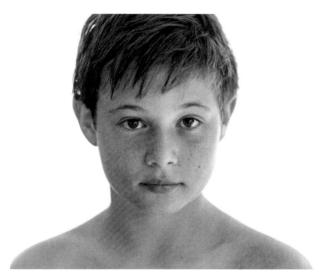

Figure 1.5 I photographed my nephew outside under a cloudy sky. The light was very soft and even, and as you can see, there are no hard shadows in the image. 1/400 second; f/2.8; ISO 400; 200mm

Figure 1.6 For this shot of musician Jessica Lerner, I used a softbox to create soft light. By placing it quite close to the subject, I made sure that it would soften (diffuse) all the light shining on her. You can see that there is a shadow, but it is not very defined, and the transition between the dark and light is quite smooth.

1/50 second; f/8; ISO 400; 62mm

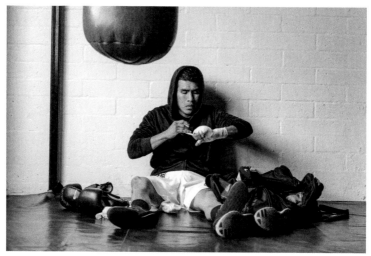

Figure 1.7 The hard light coming in through the window gave a nice dramatic look to this image of a boxer getting ready to hit the bags. The shadow on the wall behind him has a transition from light to dark that is nearly a hard line.

1/500 second; f/4; ISO 800; 60mm

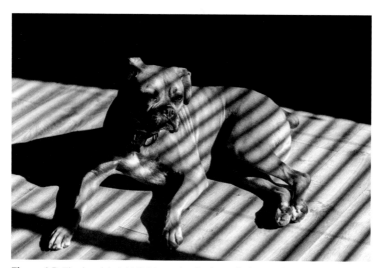

Figure 1.8 The hard, bright light coming in through the window creates hard shadows from the blinds across Hobbes.

1/1000 second; f/4; ISO 250; 105mm

Proper Color

Different types of light sources give off a different color of light. Our eyes adjust for these different colors automatically (and really quickly), so we don't really notice the vast range of color differences that we see depending on the light source illuminating the scene. But the sensor in the camera isn't as smart as our eyes yet, so we sometimes need to tell the camera what kind of light is illuminating the scene so that the image is rendered with proper color. This is done by setting the white balance on the camera. In **Figures 1.9** and **1.10**, you can see the same scene photographed with different white balance settings. We will cover ways to control the white balance in every situation in chapter 2.

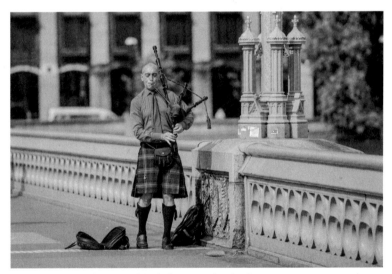

Figure 1.9 Using the auto white balance setting let the camera measure and determine the light in the scene, which rendered the image properly. All the colors look natural and, more importantly, like they did when I took the image.

1/1000 second; f/2.8; ISO 100; 200mm

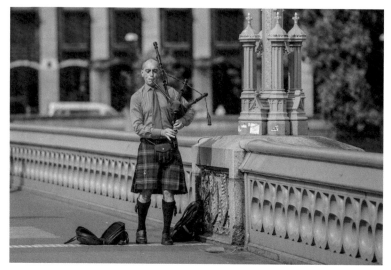

Figure 1.10 The same scene, photographed using the tungsten white balance setting. In that setting, the camera adds blue to the scene to counteract the orange given off by tungsten light. This gives the whole image a blue color cast. 1/1000 second; f/2.8; ISO 100; 200mm

Time of Day

The best light is early in the morning and at sunset (**Figures 1.11** and **1.12**). Photographers refer to these hours as the Golden Hour. The light is very soft because the angle of the sun is low on the horizon. The color is also warmer and more pleasing. That doesn't mean you shouldn't take photographs at any other time, it just means that if possible, try to photograph pretty places at the best possible time, when the beautiful light complements the subject. This is especially true when it comes to landscape photography. You will rarely find landscape photographers lining up to shoot that amazing vista at noon when the sunlight is harsh, but the same spot at daybreak or sunset could be packed with photographers and tripods. The low angle of the light creates long soft shadows that can paint a landscape as opposed to the harsh overhead light that creates hard small shadows.

Figure 1.11 As the sun started to set in Cozumel, the colors of the sky were reflected in the water, creating a much more interesting photo.

1/250 second; f/5.6; ISO 800; 70mm

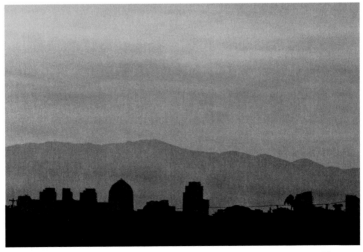

Figure 1.12 This image was taken just as the sun started to come up. There was a lot of air pollution from a recent fire, and the particles in the air made for a stunning display of colors as the low angle of the light shown through.

1/60 second; f/7.1; ISO 100; 300mm

Shutter Speed

Taking a photograph captures a moment in time. That moment can be 1/8000 of a second or hours, and everything in between. The shutter speed dictates how long the shutter is open, which dictates how movement is depicted. A short shutter speed will freeze action, while a longer shutter speeds allows the subject (or camera) to move during the exposure.

Freeze the Action

The key to freezing fast action successfully is knowing how the shutter speed works and what shutter speed you actually need to freeze motion. The simple rule is the faster the action, the faster the shutter speed needed to freeze them. You can see in **Figures 1.13–1.15** that I needed a pretty fast shutter speed to freeze the action.

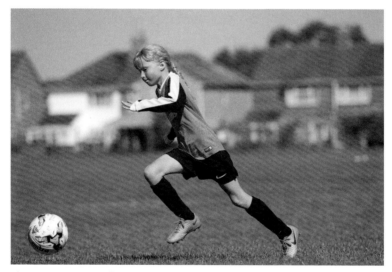

Figure 1.13 Freezing the action as the soccer player goes after the ball took a shutter speed of 1/1600 second, which froze the ball in the air and the soccer player midstride.

1/1600 second; f/3.5; ISO 100; 200mm

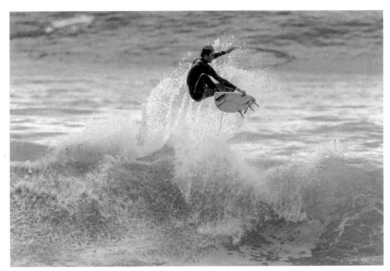

Figure 1.14 Catching a surfer getting air off the wave took a shutter speed of 1/1000 second.

1/1000 second; f/2.8; ISO 640; 400mm

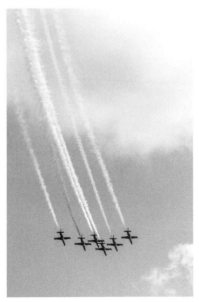

Figure 1.15 Jets move really fast, so I had to use a very fast shutter speed, 1/4000 second, to freeze the action.

1/4000 second; f/5.6; ISO 400; 300mm

Show the Motion

If a fast shutter speed is used to freeze action, a slow shutter speed can be used to show motion in your images. This can be a little tricky, since you will want something in the image to be crisp (still) so that the motion of the moving subject looks purposeful. There are two methods that will capture motion in your shot. The first is to move the camera along with the moving subject (called panning) so that the background is blurred and the subject stays in focus (**Figure 1.16**). The second is to have the camera stay still so the background stays in focus and the moving subjects are blurred (**Figure 1.17**). If everything is blurred, the image will usually just look like an out-of-focus mistake.

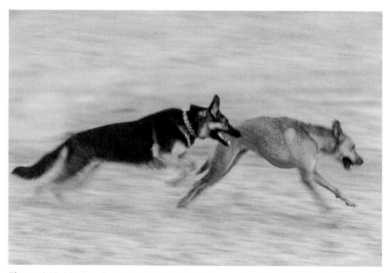

Figure 1.16 Moving the camera along with the running dog allowed for the dog to be in focus while the background (and his legs) are blurred, showing the motion in the shot.

1/50 sec; f/2.8; ISO 800; 200mm

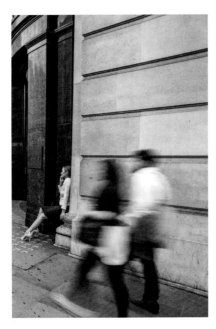

Figure 1.17 The slow shutter speed allowed the couple walking through the frame to be blurred while the background stays in focus.

1/5 second; f/5.0; ISO 200; 20mm

Aperture and Focus

The aperture controls the size of the opening in the lens that allows light into the camera. The aperture also controls the depth of field, which refers to the range of depth in your image that will appear in focus. Controlling what is in focus and what is out of focus in your image is possibly the greatest control you have over the photo because the in-focus elements attract the viewer's attention.

NOTE

When it comes to describing the aperture, the number (e.g., f/3.2) is a fraction, so the bigger the number, the smaller the opening.

Subjects Pop Off the Background

Controlling the depth of field allows you to control how much of the image is in focus. Using a shallow depth of field can focus the attention on your subject by really making it pop out of your image. A shallow depth of field allows you to isolate a very precise area of the frame to be in focus against a background thrown out of focus (**Figures 1.18** and **1.19**).

Everything in Focus

There may be times when you will want to have everything in the frame in acceptable focus. This means that the items in the front, the middle, and the back of the frame all look sharp. To get everything in focus, you need to use a small aperture, which creates a very deep depth of field. The main issue with using a small aperture (opening) in the lens is that you need a slower shutter speed (which allows more light into the camera) to get a proper exposure (**Figures 1.20** and **1.21**).

Figure 1.18 The background in this image is some nice green bamboo; but by using a shallow depth of field (f/3.2), it becomes a pleasant green blur, making the subject in front of it really stand out.

1/250 second; f/3.2; ISO 400; 200mm

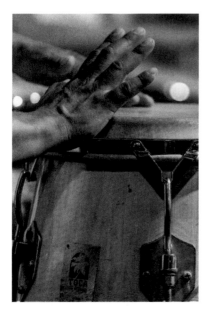

Figure 1.19 Focusing on the right hand of the drummer and using a very shallow depth of field (f/2.8) keeps the attention right on the action while the background is a nice blur.

1/5 second; f/5.0; ISO 200; 180mm

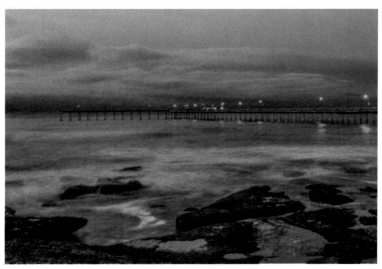

Figure 1.20 Using an f/19 aperture allowed for the rocks in the foreground and the pier in the background to be in sharp focus. The camera was set on a tripod to reduce any shaking caused by the very slow shutter speed.

4 seconds; f/19.0; ISO 100; 35mm

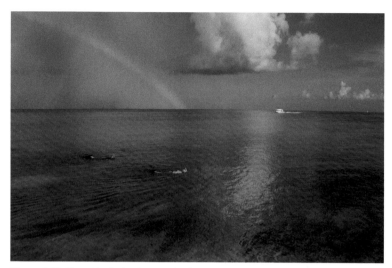

Figure 1.21 To get both the boat in the background and the snorkelers in the foreground in focus, I need to use a small aperture, in this case f/16. For this photo, the bright sunlight allowed me the option to use a fast-enough shutter speed, thus eliminating the need for a tripod.

1/400 second; f/16; ISO 400; 27mm

Focal Length / Lens Choice

The first compositional choice that you make as a photographer is what lens to use. Are you using a prime lens with a single focal length or a zoom lens that covers a wide range of focal lengths? Are you using a telephoto lens or a wide angle? Some lenses give you a huge range of focal lengths (like the 18-400mm Tamron), while others cover a smaller range (the 24-70mm Nikkor).

There are a few things that you need to know about focal lengths and how they impact the items in your photos. First, a larger focal length will capture a smaller area of the scene in front of the camera and gets you closer to the subject. A smaller focal length will capture a larger amount of the scene. All the ins and outs of the different lenses and their terminology is covered in depth in chapter 4, but for now, it is fine to just think in terms of wide and telephoto lenses, as seen in **Figures 1.22** and **1.23**.

Figure 1.22 A wide-angle lens shows a wide view of the area in front of the camera. For this photo of the Dallas Opera house, I used a super-wide-angle lens to get the whole interior of the house into a single shot.

1/25 second; f/5.6; ISO 800; 18mm

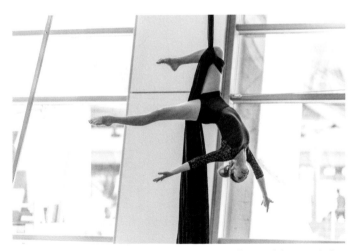

Figure 1.23 A telephoto lens only captures a small part of the area in front of the camera, which brings that subject much closer to the camera. Here, I used a 70-200mm f/2.8 lens at 200mm to get in close to the aerial performer while she was way up in the air.

1/500 second; f/2.8; ISO 400; 200mm

Compositional Basics: Rule of Thirds

One of the simplest, yet most effective rules of composition is called the rule of thirds. It works by dividing the scene into thirds both vertically and horizontally (as seen in **Figure 1.24**), and then placing the most important subject at the intersections of those lines, as seen in **Figures 1.25** and **1.26**. You can also use this principle when deciding where to place the horizon line in an image—either a third from the top or the bottom (**Figure 1.27**) of the frame. The rule of thirds and the other rules of composition are guidelines that can help you take better photos.

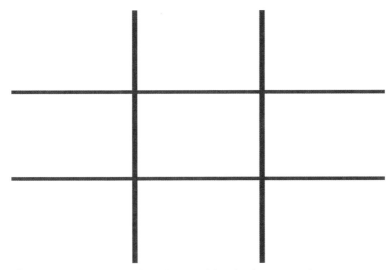

Figure 1.24 The rule of thirds grid is one of the simplest ways to improve your composition. Just imagine this grid over your scene, and place the important subjects at the intersection of the lines.

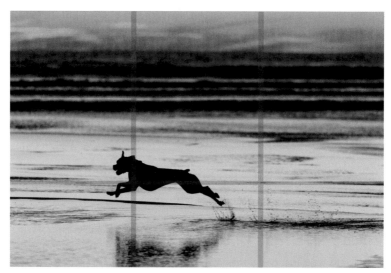

Figure 1.25 I placed the running dog in the bottom left of the frame using the rule of thirds as a guide.

1/1000 second; f/2.8; ISO 1600; 140mm

Figure 1.26 When photographing people, I try to use the rule of thirds by placing an intersection point right over one of their eyes.

1/500 second; f/5.6; ISO 800; 85mm

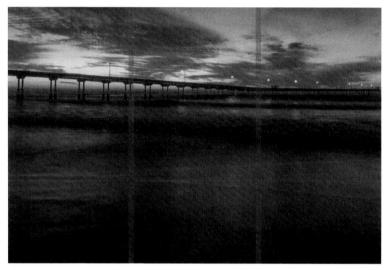

Figure 1.27 When shooting landscapes, place the horizon line either 1/3 of the way up from the bottom or 1/3 of the way down from the top of the frame, depending on whether you want more of the sky or the ground in the image. In this case, it was the wet sand in the foreground that was more interesting, so I placed the horizon line 1/3 of the way down from the top of the frame.

1/60 second; f/16; ISO 200; 20mm

PRACTICE

Give This a Try

One of the best ways to improve your photography is to study the photos you have already taken. Now that we've looked at elements that can make a better photo, look through your recent photos that you really like, and take a closer look at them. What is it about them that you like? Keep these ideas in mind and incorporate them into future shots.

Take It a Step Further

Take a look at some of your favorite photographs by other people—it could be the work of a friend on Facebook or Instagram, or shots by a famous photographer you admire. What excites you about these images? Is it the subject, the light, the composition, or the way your eye is drawn into the image? Pull inspiration from your favorite shots and learn from the work of other artists.

Notes

IT'S ALL ABOUT THE LIGHT

Photography books can spend a lot of time on light, and for good reason: it really is that important. I'm going to keep it simple so you can spend more time learning by taking photos. After you go out and take some shots, you will start to see that certain light just looks better.

Why Light Is Important

When you take a photo, you are actually capturing the light that is bouncing off of the subject. The sensor (or film) is recording the light as it enters the camera, focused through the lens. Light is important to photography because it is what's being captured when the shutter moves out of the way and the image is created. Photographers need to know how bright the light is, as well its color and direction. Here are four different factors to consider when thinking about the light in the scene.

- **Intensity of the Light:** How bright is the light in your scene? Are you outside in the middle of the day with a cloudless sky, or are you in a dark room that is only lit with a table lamp? The intensity (or amount) of light will determine what exposure settings are needed to make a proper exposure. **Figure 2.1** was taken outside under a clear, bright sky, so there is a lot of very brilliant light. **Figure 2.2** was taken after the sun set, so there is a lot less light in the scene.

Figure 2.1 There is a lot of bright light in this scene, because it was shot during the middle of the day, outside, under a cloudless sky. You can see that the light is overhead by the direction of the shadows.

1/400 second; F/10.0; ISO 200

- **Quality of the Light:** An easy way to tell if the light in your scene is hard or soft is to look at the edge of the shadows. A hard-edged shadow means a hard light, while a soft-edged shadow means a softer light. Soft light was used to take the portrait in **Figure 2.3**.

- **Color of the Light:** Light has color that can affect how things look in your photos. Every light source gives off light with a different color cast. The color of light produced by a candle flame is very different from the color of light produced by fluorescent bulbs.

Figure 2.2 Photographing at night means that there is less light in the scene. Here, you can see the city lights in the distance under the bridge. I needed a longer shutter speed to allow enough light to reach the sensor to create this photo.

24 seconds; F/16; ISO 200

Figure 2.3 As you can see, there are no hard shadows in the portrait of Elina. The light was diffused and very soft and flattering.

1/250 second; F/5.6; ISO 400

The color of the light is determined by its source, the color of the surface it's bouncing off of, and whether or not it's passing through anything. If you are photographing someone standing next to a colored wall or door, the light bouncing off the colored surface can color the subject. You can intentionally color your light by shining it through a colored object, like a gel.

Regardless of its color, light looks colorless to our eyes because our brains adjust to it almost instantaneously. But the sensor in the camera needs help adjusting to the different colors of light. The White Balance setting in your camera allows you to tell the camera which type of light is illuminating the scene so the sensor can render the colors in the shot more accurately. The Auto White Balance setting tells the camera to automatically adjust for the color of the light with every photo. This works well in most circumstances and is what my camera is set to by default. Setting the proper white balance can make all the difference. In **Figures 2.4** and **2.5**, you can see the same scene shot using different white balance settings. Which one looks more natural to you? Check your camera manual for more information on the White Balance settings for you camera.

- **Direction of the Light:** Is the light coming from the sides, the front, or from behind the subject? The direction of the light will help you determine where to place the subject, or where to place yourself to get the best result. The easiest way to determine the direction of the light is to look at where the shadows fall (**Figure 2.6**).

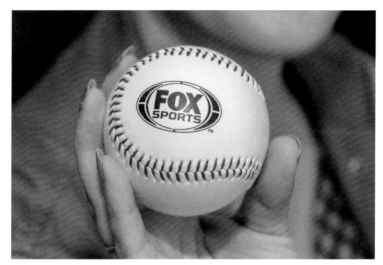

Figure 2.4 We know that a baseball is supposed to be white. In this shot, the White Balance was set to Daylight, creating a natural look for the ball and the hand holding it.

1/125 second; F/6.3; ISO 200

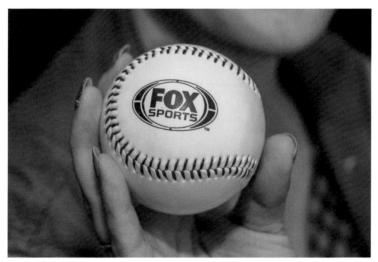

Figure 2.5 In this shot, the white balance was set to Tungsten, which added a blue cast to the image. This does not look natural at all.

1/125 second; F/6.3; ISO 200

Figure 2.6 It's pretty easy to see that the light is coming from the left in this image—just look at those long shadows stretching out to the right.

1/800 second; F/4.5; ISO 400

Exposure

Exposure is the process where the light enters the camera body through the lens and is recorded by a light-sensitive sensor (or in the pre-digital days, the film). The amount of light that reaches the sensor is controlled by the size of the opening in the lens (aperture), the amount of time the shutter is open to allow light to reach the sensor (shutter speed), and how sensitive to light the sensor acts (ISO). Getting the right amount of light to the sensor will result in a well-exposed photo (**Figure 2.7**). Too much light results in an overexposed image (too bright) (**Figure 2.8**), and too little light results in an underexposed image (too dark) (**Figure 2.9**). The goal is to use the shutter speed, aperture, and ISO to allow the right amount of light to be captured.

Figure 2.7 A proper exposure.
1/4000 second; F/2.8; ISO 400

Figure 2.8 This image is overexposed.
1/4000 second; F/2.8; ISO 400

Figure 2.9 This image is underexposed.
1/4000 second; F/2.8; ISO 400

The EV or Exposure Value is the number used to describe the current amount of light reaching the sensor. It deals with three separate settings (the amount of time the shutter is open, the size of the aperture, and the sensitivity of the sensor) that are all adjusted in different ways. I find it's easiest to not worry about the individual settings and just think of the EV as an overall gauge of light with negative numbers on the left, zero in the middle, and positive numbers on the right (**Figure 2.10**). If the camera thinks the image will be too bright, the gauge goes into the positive. If the camera thinks the image will be too dark, the gauge goes into the negative. If the reading is at zero, the camera thinks the exposure is correct.

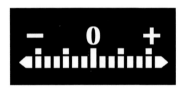

Figure 2.10 The Exposure Value (EV) gauge.

If you use any of the exposure modes other than Manual, the camera will do everything it can to keep the EV at zero by automatically adjusting the shutter speed, aperture, and even the ISO. In Manual mode, the camera will show you the current EV, and you'll have to dial in the adjustments.

In determining the EV reading, the camera takes the information from the built-in light meter and calculates settings that will take a shot in which the dark and light areas in the scene average out to 18% gray. This works quite well when you use the best metering mode for the subject, but it isn't perfect, especially when there are large dark areas or large bright areas in the scene (**Figures 2.11–2.13**).

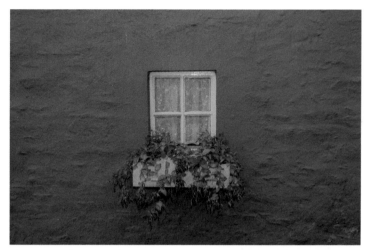

Figure 2.11 The wall and widow had no very dark or very bright areas, so the camera had no trouble getting the exposure just right. Because the light was even throughout, the camera metered for the average light in the whole scene.

1/125 second; F/5.6; ISO 125

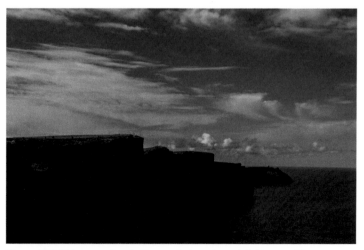

Figure 2.12 This scene has both very dark and very bright areas. The camera metered off the brightness of the sky in an attempt to expose for the bright areas, which made the cliffs that were in shadow go even darker. Most of the detail is lost.

1/320 second; F/9; ISO 200

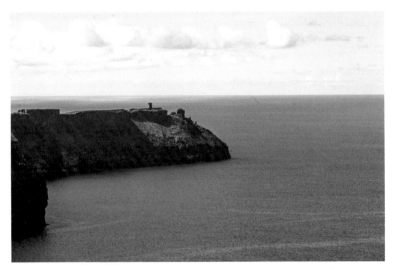

Figure 2.13 This is the same shot as in Figure 2.12, but now the camera is metering for the darker area of the cliffs, which makes the sky appear overly bright

1/250 second; F/8; ISO 200

What's a Stop

The EV gauge is measured in stops. In photography, a stop is the change in the amount of light hitting the sensor. If you change your settings to let in twice as much light, that equals one full stop. If you change your settings to let in half as much light, that change is also a full stop. The shutter speed is measured in time, so when you double the time the shutter is open, twice as much light reaches the sensor. When you halve the time the shutter is open, it lets in half as much light. Both of these are a full-stop difference in the light. The same goes for doubling or halving the size of the aperture or the ISO to change the EV by a full stop.

Different exposure settings can give you the same exposure. These equivalent exposures all have the same EV, but the shutter speed, aperture, and ISO settings are different. Look at **Figures 2.14–2.15**: these two images of the same scene each have an EV of 0, but different settings, which give them a very different look.

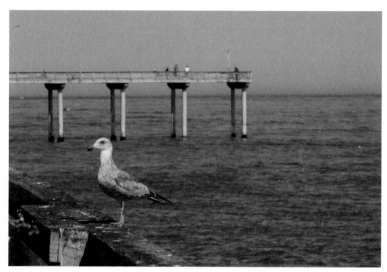

Figure 2.14 A seagull photographed with a wide-open aperture and fast shutter speed blurs the background and keeps the attention on the bird.

1/4000 second; F/2.8; ISO 100

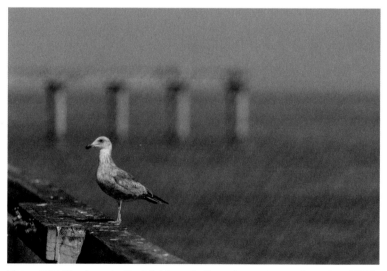

Figure 2.15 The deep depth of field created by using a very small aperture (f/22) allows the whole scene to be in acceptable focus.

1/60 second; F/22; ISO 100

Let's look at the mathematical aspects of these two exposures. I started with a wide aperture of f/2.8 and went to a much smaller aperture of f/22. This accounts for six full stops of change: f/2.8, f/4, f/5.6, f/8, f/11, f/16, f/22. That means that I need to adjust the shutter speed and the ISO for a total of six full stops as well. I started out at 1/4000. The shutter speed changes by six stops as follows: 1/4000, 1/2000, 1/1000, 1/500, 1/250, 1/125, 1/60. The new shutter speed is 1/60 of a second. While mathematically speaking, the two images have the same exposure, the way they are captured is vastly different when it comes to what's in focus and what is out of focus.

The Four Basic Exposure Modes

There are four basic exposure modes: program auto, shutter speed priority, aperture priority, and manual (**Figure 2.16**).

- **Program Auto:** This mode gives the camera the most control. This mode will try to take a properly exposed image by balancing the aperture with the shutter speed. It is a great place to start and will produce pretty good results. The problem is that you have very little control over the look of the image. This mode works best as a snapshot setting. I don't use it much anymore, but when I first started in photography, I used the program auto mode on the camera to see what the camera thought was the proper exposure. I recommend it for people who are just starting out and don't really care about the control the other modes give you. You have some control over the final image; you can adjust the shutter speed or the aperture after the camera has decided on the settings and the camera will automatically adjust the other settings.

- **Shutter Speed Priority (Figure 2.17):** In this mode, you set the shutter speed and the camera sets the aperture based on the amount of light the camera sees in the scene. Use this mode when you want control over how motion in the image is rendered. Higher shutter speeds freeze the action and slower shutter speeds show movement in streaks.

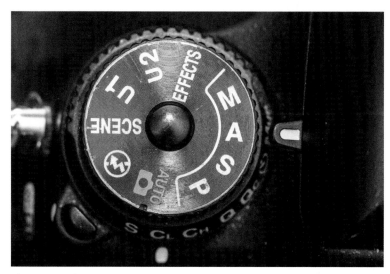

Figure 2.16 The exposure mode dial on the Nikon D750.

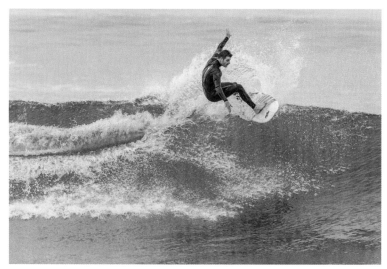

Figure 2.17 I use shutter speed priority when I care more about freezing (or showing) motion than I do about the depth of field. Here, I wanted to make sure that I froze the surfer on the wave, so I used a 1/1000 of a second shutter speed in shutter speed priority mode.

1/1000 second; f/4.0; ISO 500

- **Aperture Priority (Figure 2.18):** In this mode, you set the aperture and the camera sets the shutter speed based on the meter reading. Use this mode when the depth of field is the most critical choice in your image. Smaller apertures create a deeper depth of field while larger apertures create a shallow depth of field.

- **Manual (Figure 2.19):** In this mode, you set the aperture and the shutter speed, and the camera does nothing. This mode gives you the most control over your images. While the camera won't adjust any of the settings you choose, it will tell you if it thinks the settings will result in an over- or underexposed image.

Figure 2.18 Here, I used an aperture of f/16 to get everything in the scene in acceptable focus. Using aperture priority allows me to make sure that the depth of field is exactly what I want. The camera then sets the shutter speed accordingly.

1/500 second; F/16; ISO 400

Figure 2.19 When I photograph concerts, I use the Manual exposure mode so that I can deal with the rapidly changing lights. Here, I used a shutter speed of 1/250 to freeze the action, an aperture of f/2.8, and an ISO of 1600 to get the proper exposure.

1/250 second; F/2.8; ISO 1600

The Scene Exposure Modes, and Why I Don't Use Them

Some cameras have a set of exposure modes that are designed for specific subjects, and are usually shown as little icons on the camera. The scene modes usually include landscape, portrait, child, close-up or macro, sports, and night modes, which are designed to take the best shot in applicable situations. These modes can help amateurs get better images in specific scenes, but there is a flaw. These modes give the camera a lot of control without actually letting the photographer know what is going on. You can get the same (or better) results using one of the four basic exposure modes (P, A, S, or M), and then you know exactly what the camera is doing. It's a better idea to just understand the basic exposure modes and set the camera for your specific situation. The pro-level cameras don't have scene modes because the pros don't use or need them.

Metering Modes—How Your Camera Measures the Light

The camera uses its built-in light meter to look at the amount of light in the scene and set the exposure controls (shutter speed, aperture, and even the ISO in some cases). This is called metering. Every camera has at least three basic metering modes, which allow you to decide what the camera looks at when measuring the light: spot metering, center-weighted metering, and full-scene metering.

- **Spot Metering:** This mode only measures the light in a very small part of the scene, allowing you to take a very precise meter reading for a particular area. This mode works best when the subject is surrounded by large dark or bright areas (**Figure 2.20**).

- **Center-Weighted Metering:** This mode looks at most of the scene, but gives more importance to the stuff in the middle of the frame. This mode is best when the edges of the frame are bright or dark. I mainly use this mode for portraits where the background is either very light or very dark (**Figure 2.21**).

- **Scene Metering:** This mode has different names depending on the camera brand. It can be called matrix, multi-segment, or evaluative metering. This mode looks at the whole scene, then divides it up into smaller parts, and reads the light in each part. Using a combination of technology, databases, and maybe a touch of magic, scene metering decides what is important and what can be ignored. This mode works really well for most situations and is the metering mode my camera is set to by default (**Figure 2.22**).

Figure 2.20 When using spot metering, the camera only looks at a small part of the scene (in red) and ignores the rest.

Figure 2.21 Center-weighted metering focuses on what's in the middle of the frame.

1/4000 second; F/2.8; ISO 400

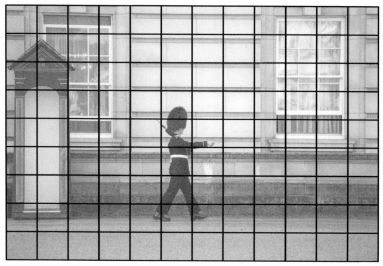

Figure 2.22 In scene-metering mode, the camera divides the whole scene into small parts, measures the light in each part, then averages them all together. 1/4000 second; F/2.8; ISO 400

Exposure Compensation Made Simple

By adjusting the EV value from zero to either a positive or negative, exposure compensation allows you to tell the camera to make a photo lighter or darker without changing the metering mode or the exposure mode. This is really handy when you don't agree with the settings the camera is using. Instead of looking for a different part of the image to meter the light or changing to Manual mode, you can adjust the exposure using the exposure compensation control. If the important part of the image is too bright, dial in a negative number to make the image darker. If the image is too dark, dial in a positive number to make the image brighter. You can see the difference in **Figure 2.23**, and **Figures 2.24** and **2.25**. I dialed in a -2 to make Figure 2.24 two stops darker, and +2 to make Figure 2.25 two stops brighter.

Figure 2.23 This is the base photo that was set to aperture priority using an aperture of f/5.6. The camera then looked at the scene using Matrix metering and picked 1/320 second as the shutter speed.

1/320 second; F/5.6; ISO 200

Figure 2.24 This is the same scene as in image 2.23, but now -2 exposure compensation has been applied. This darkened the scene by two full stops of light and since we are using aperture priority, the camera adjusted the shutter speed to make the image darker.

1/800 second; F/2.8; ISO 200

Figure 2.25 I dialed in a +2 exposure, making this image much lighter. In this case, the camera dropped the shutter speed to 1/80 seconds.

1/80 second; F/5.6; ISO 200

Let's look at how this works, because it can have some unwanted side effects. The camera looks at the light using the selected metering mode and then decides what settings will give you a proper exposure. When you apply exposure compensation, the camera adjusts the settings to allow more or less light to reach the sensor, making the image brighter or darker, by adjusting the aperture or the shutter speed (or both), depending on the exposure mode selected.

- **Program Auto Mode:** The camera will adjust either the shutter speed or the aperture or both, depending on the amount of light. This mode gives you the least amount of control over the scene.

- **Manual Mode:** The exposure compensation does nothing.

- **Shutter Speed Priority Mode:** You set the shutter speed and the camera sets the aperture. This works well until the camera is already at the widest aperture, but still needs more light. At this point, the camera takes a photo with the widest possible aperture—the image won't get any lighter unless you use a slower shutter speed.

- **Aperture Priority Mode:** You pick the aperture and the camera sets the shutter speed. When you apply exposure compensation, the shutter speed increases to let in less light to make the image darker, or reduces the shutter speed to allow in more light to make the image lighter. When the shutter speed drops so low that the image is blurred, it may be necessary to adjust the aperture, as well.

How Sensitive Is Your Camera to Light

The ISO setting controls how sensitive to light the sensor acts (**Figure 2.26**). The higher the ISO, the less light is needed to create a good exposure. The sensor doesn't actually change—instead, the camera boosts the information being recorded.

Figure 2.26 The ISO range on the Nikon D750

ISO settings work the same as shutter speed and aperture when it comes to exposure. Each full-stop change in the ISO makes the sensor act half or twice as sensitive to light. For example, ISO 200 is half as sensitive as ISO 400, meaning you need twice as much light to reach the sensor. ISO 800 is twice as sensitive as ISO 400, meaning you need half as much light to reach the sensor.

The full-stop ISO range looks like this: 50, 100, 200, 400, 800, 1600, 3200, 6400, 12800, and so on. Each of these changes is one full stop of light. Cameras will usually allow you to adjust the ISO in 1/4 or 1/3 stops as well, giving you more precise control over the exposure.

ISO as Your Secret Weapon

When it comes to camera settings, the ISO is often the last thing that photographers think of (if they think of it at all). Start thinking of the ISO as the secret weapon that allows you to get a light-enough exposure while still using the shutter speed and aperture you want so that your photos look the way you want them to. If you need to freeze the action with a fast shutter speed, start with a higher ISO. If you need to shoot in low light with a long depth of field, try using a higher ISO. If you need to use a wide aperture outside in bright light, start with the lowest ISO on your camera. Many cameras allow you to pick the shutter speed and the aperture, then the camera picks the ISO based on the meter reading. This is the Auto ISO setting. This setting allows the camera to automatically adjust the ISO when needed.

Digital Noise Isn't a Problem...Anymore

Digital noise is the little specs of color that appear in your image when using very high ISOs, or when you leave the shutter open for a very long time. Camera manufacturers have really improved the sensor's ability to capture photos in low light at high ISOs with very little noise. Take the young jaguar in **Figure 2.27**: I photographed this happy young cat at the zoo, through a glass wall, in very low light. I used an ISO of 1600 to get the exposure settings I needed, and as you can see, there is no (or very little) noise.

Digital Noise Reduction

Dig through the menu settings on just about any DSLR and you will find a Noise Reduction setting. This setting tries to reduce the digital noise created when you take a photo using a high ISO or a very long shutter speed (**Figure 2.28**). I make sure all of these settings are turned off before taking photos. They add a lot of extra time to the image-creation process, and the results are not that great. You can get better results if you do noise reduction in post-production using software like Photoshop or Lightroom. These editing tools have also been improved drastically over the years to help remove the digital noise from photos without harming the image.

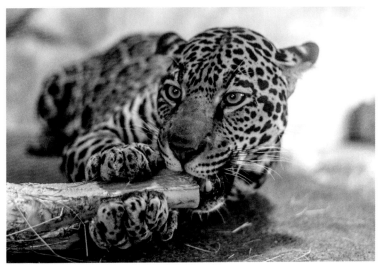

Figure 2.27 This photo of a jaguar cub chewing on a snack at the zoo needed an ISO of 1600, yet there is little to no visible noise.

1/60 second; F/1.8; ISO 1600

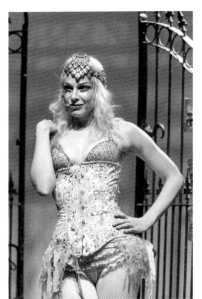

Figure 2.28 This image of Emily was shot in very low light during her performance. I used an ISO of 6400, and while there is a little noise in the image, it's unnoticeable unless you were looking at a huge print or the image zoomed in on a computer screen to 100%.

1/80 second; F/2.8; ISO 6400

PRACTICE

Give This a Try

Picking the right exposure mode for each situation means you have
to understand what each exposure mode does. You can explore these
modes to get comfortable with how they render images without
even leaving the comfort of your living room. Pick a subject and take
four photos of it, one in each of the main exposure modes. Study the
results to see how the camera reacts and what settings the camera
picks in each mode.

Give This a Try

Using the right metering mode is critical. It determines what light
the camera is looking at when it sets the exposure. Again, you can
explore these modes by taking test shots of subjects in your home and
studying the results.

Take It a Step Further

When you have an understanding of how the metering modes and
exposure modes affect your images, experiment with using different
combinations of exposure and metering settings. Set the camera to an
exposure mode, and then take a photo of the same scene using each
of the metering modes. Repeat this for each of the exposure modes
until you have a set showing what happens with each combination.
Look at the images; some will look alike, but there should be some
differences in the areas of light and dark captured in the image. This
should help you to understand the different modes and how they will
capture the scene in front of the camera.

Notes

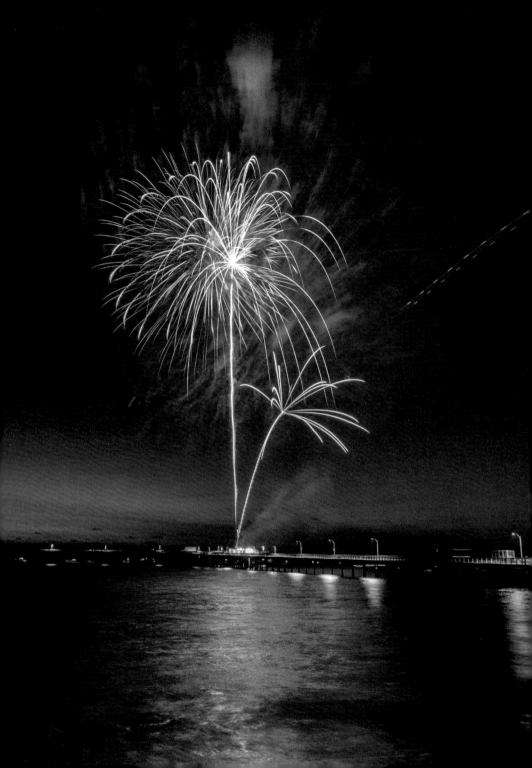

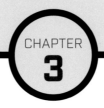

GETTING THINGS IN FOCUS

There is nothing as disappointing as looking at an image and realizing that the main subject is out of focus. You think the shot is great, and it looks good on the screen on the back of the camera, but when you get it back to the computer or print it out, the subject is soft, slighty blurry, and there is very little that can be done to fix it. Nothing can ruin a great photo as quickly as an out-of-focus subject. Picking the right focus mode, the right focus area, and the right focus point can all help in making sure that the focus is right on the subject. Understanding the roles that shutter speed and apertures play in focusing the scene will let you control what is in focus and what is not.

The Different Focus Modes Explained

There are three basic focus modes: Single Subject AF, Continuous AF, and Manual focus. Each of these focus modes works in a different way, and it is up to the photographer to pick the right focus mode for specific situations. Let's look at each mode in detail and discuss the best time to use them.

Single-Subject Autofocus

In this mode, the camera starts to focus when the shutter release button is pressed halfway down. Once the focus is locked, the camera stops trying to focus. If the subject or the camera moves after the focus is locked, the camera will not try to refocus until the photo is taken or the pressure is removed from the shutter release button and then reapplied. This focus mode is best used for subjects that are

stationary, like landscapes or still-life scenes (**Figures 3.1** and **3.2**). This mode can also be used when you want to place the subject in the frame at a point where there are no focus points, but where you want to first achieve focus, and then recompose the scene. The key is to make sure that you are not changing the distance between the subject and the camera when recomposing so that the subject stays in focus.

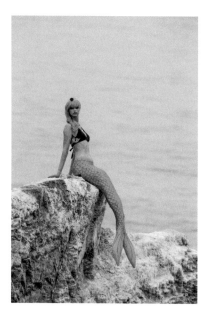

Figure 3.1 This lovely mermaid figure showed up mysteriously at Ocean Beach, and was there for a few days before mysteriously leaving. I used a single-subject autofocus since the statue was not moving and neither was the camera.

1/1000 second; F/5.6; ISO 400

Continuous Autofocus

Continuous AF is used for photographing moving subjects. The camera starts focusing when the shutter release button is pressed halfway down, and keeps focusing right until the image is taken. This mode keeps adjusting the focus right up until the shutter release button is pressed all the way down. This mode is best for any subject where the camera or the subject is moving, like sports and concerts (**Figures 3.3** and **3.4**). I also use this setting for portraits, candids, and just about any time I do not have the camera locked down in a tripod.

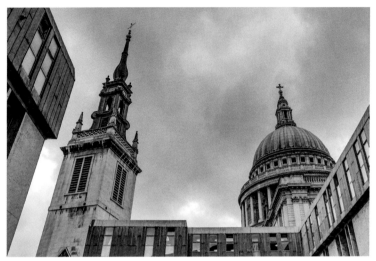

Figure 3.2 Single-subject autofocus is great for landscapes and cityscapes. I took this while walking around the St. Paul's area of London.

1/320 second; F/5.6; ISO 200

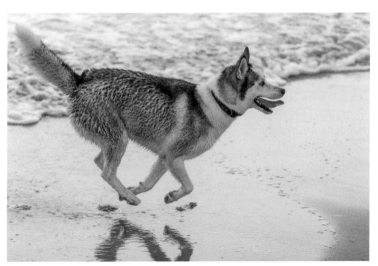

Figure 3.3 Continuous AF is best used for moving subjects, like the dog in this photo. The camera kept focusing until I pressed the shutter release button all the way down.

1/1000; f/2.0; ISO 1600

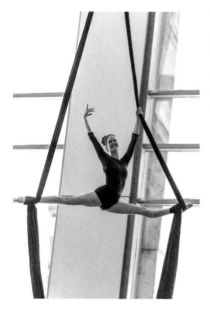

Figure 3.4 When I photographed Jennifer during her aerial performance, I made sure the camera was using continuous autofocus since she never actually stopped moving.

1/400 second; F/2.8; ISO 600

NOTE

Some cameras have a hybrid still/continuous focus mode that tries to be the best of both worlds. In this mode, the camera starts to focus when the shutter release is pressed halfway down. If the subject is still, then the camera stops focusing; if the subject starts to move, the camera will (hopefully) start to focus again. My advice is to skip this mode and stick with the basics: either continuous AF or Single Subject AF.

Manual Focus

In this mode, the camera doesn't focus automatically at all. Instead, the photographer needs to turn the focusing ring on the lens to find focus. This is useful for scenes with very low contrast where the camera can't lock focus on its own or when the focus is really critical, like in macro photography (**Figure 3.5**).

To access manual focus, you will have to turn off the autofocus, either on the camera body or on the lens itself. Check to see if the lens has a switch (like that shown in **Figure 3.6**), then switch from autofocus to manual focus. When you look through the viewfinder and turn the focusing ring on the lens, you will see the focus adjust.

Another time that using manual focus is the way to go is when you don't want the camera to hunt for focus because the focus point is set, and the distance between the subject and the camera isn't going to change. The best example of this is photographing fireworks. You do not want the camera to try and focus each and every time a firework is launched. Instead, you focus once and then turn the focusing system off. This stops the camera from waiting to achieve focus before starting the exposure.

Focus Points

When I picked up my first camera, there was no autofocus. You just turned the focusing ring on the lens until the subject was in focus, then you took the photo. This could be difficult to do, especially with moving subjects, but it gave you complete control over what was in focus and what was not. Then autofocus came about, and the camera focused on the subject for you based on the scene, but you couldn't tell the camera what the subject was, and what to focus on. Now cameras use focus points (AF points) for autofocus. You select the focus points to let you decide what the camera will focus on in the frame. Many cameras have a lot of focus points, allowing you much more control over where the camera will focus. Take the Nikon D850, which has over 150 focus points (**Figure 3.7**), or the Canon EOS 5DS, which has 61. As you can see, the AF points do not go all the way from edge to edge or from top to bottom of the frame, but are positioned in the middle. Decide which of these points to use, align them with the subject, and press the shutter release halfway down to activate the autofocus.

Figure 3.5 Using manual focus can really help with those critical focusing situations—especially when shooting macro images. Here, I needed to manually focus on just the tiny bud at the top of the plant—not on the leaves closest to the camera.

1/500 second; F/8.0; ISO 400

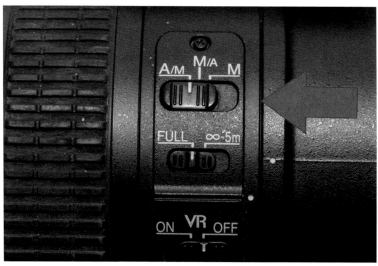

Figure 3.6 The switch on the Nikkor 70-200mm f/2.8 allows you to choose between the lens being in autofocus or manual focus.

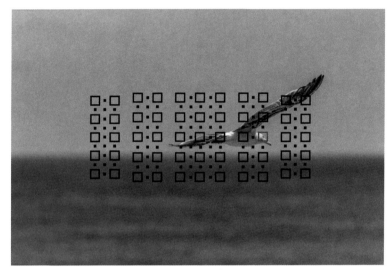

Figure 3.7 The Nikon D850 has 153 AF points, which allows you to pick exactly what to focus on—in this case, the bird's eye.

1/2500 second; F/4; ISO 200

AF Areas

You choose which focus points to use (and how many of them to use) by selecting an AF area. Each AF area offers a different option for how the focus points are used to focus your camera.

Single Point

In single-point AF area mode, the camera uses just one of the AF points, giving you the most control over what the camera looks at and focuses on. Single-point mode is perfect for portraits: as you can see in **Figure 3.8**, the focus point is right on the eye of the subject. The downside to using just a single point is that the camera might have a problem achieving focus depending on the subject and how much contrast there is in the very small focus area.

Figure 3.8 Using just a single AF point allows you to decide exactly what point will be in focus. Here, the focus point is right over the subject's eye.

1/2500 second; F/3.2; ISO 100

I use the single-point AF mode a lot, especially when photographing concerts. It allows me to focus on the performer and not the microphone, which is usually close to their mouth (and in between them and the camera).

Multiple Points (Dynamic Autofocus)

In multiple points (dynamic autofocus) mode, you pick a single AF point, but the camera uses the surrounding AF points to help focus. This is particularly useful when you are trying to keep a moving subject in focus. In **Figure 3.9**, you can see the two dogs running on the beach, and the active focus points in red. I picked the middle AF point, and the camera used the surrounding points to help keep the autofocus locked on the subject.

When using multiple AF points, you still need to pick the main AF point that the other AF points are supporting. Since every camera model is different in terms of their number of AF points, check your camera manual for the exact number of available AF points and groups on your camera.

Figure 3.9 Using nine AF points to keep the running dog in focus works really well as long as there is enough information available in the scene for the autofocus system to use to sense the subject. With the dogs in this photo, the contrast between the white and tan markings, and the details in the mouth and eyes gave the camera enough information to keep the subjects in focus.
1/4000 second; F/4; ISO 800

My preference when using multiple AF points is to use the smallest number of points available (usually nine points). This gives me the accuracy of the single point but with the ability to track the subject, which gives me more sharp images—especially with erratic-moving subjects. In **Figure 3.10**, you can see how using multiple points helps with photographing fast-moving sports like hockey. The main point is right on the player's face, but the surrounding points help when other players (or officials) cross in front of the subject.

Figure 3.10 A single point is used to focus on the player's face, and the surrounding points help make sure the player stays in focus, even with other objects or people moving through the shot.

1/500 second; F/2.8; ISO 1600

Group AF

This is a newer autofocus mode in which the camera uses a group of AF points as a single, larger autofocus point (**Figure 3.11**). I have been using this mode on the newer Nikon cameras for a while and really like it for sports and action photography. Instead of using a single AF point and then having the surrounding points help keep the autofocus locked on a subject, this mode uses a small grouping of AF points, but treats them as a single, larger point. The Canon cameras have zone AF modes in which a group of AF points are used together. The camera focuses on the closest subject covered by that zone. These group AF modes increase the speed of the autofocus, allowing you to get sharp images very quickly.

Figure 3.11 The Group AF on the Nikon D750 allows me to use a group of AF points as a larger, single AF point. This helps keep focus when photographing fast-moving subjects, especially in situations when you might not have enough contrast on the subject to use a single AF point, like with this seagull.

1/4000 second; F/5.6; ISO 100

All the AF Points (Auto-Area Mode)

This is my least favorite mode (and I seldom use it) because it gives control of what is in focus to the camera. In this mode, the camera used to pick whatever was closest to the camera and focus on that. The newer technology available allows for more sophisticated techniques, such as facial recognition, where the camera tries to focus on the person in the frame.

This mode is best suited for those who feel overwhelmed by trying to use their camera's multiple AF points. Most of the time, the camera will try to focus on what is closest to the camera. Knowing this lets you use this mode to get what you want in focus—just make sure there is nothing between your subject and the camera that could pull focus (**Figure 3.12**).

Figure 3.12 The auto mode activates all the AF points and the camera picks the ones to use. This works well for landscapes and other scenes where there is nothing between the camera and the subject, like this photo of the front of a cathedral.

1/400 second; F/10.0; ISO 200

Back-Button Focus Explained

The default setting for most cameras is to have the autofocus activate when you press the shutter release button halfway down. But many cameras allow you to assign the autofocus to a different button so that the autofocus activation and the shutter release aren't connected. There are some really good reasons to try this, especially if you are shooting moving subjects; but be warned, it does take some getting used to.

The first advantage is that your camera keeps focusing as you hold the assigned focus button down, and stops trying to focus if you let go. This helps when photographing a subject that is moving among other subjects. For example, think about photographing a sporting event like a soccer or football game where you are focusing on the player running with the ball and the referee or another player gets between

you and the subject (**Figures 3.13** and **3.14**). If your focus is tied to the shutter release button and you keep taking photos, the focus is going to jump to the subject closer to you (that's what autofocus does) as you put pressure on the shutter release button. If you use a different button for focus, you can stop the autofocus by removing pressure from that button and still take photos of the subject using the shutter release button.

The second advantage is that when the focus is tied to the shutter release button, the camera has to stop focusing for a split second as the photo is taken; it starts to refocus as you press the button down again. This means you could lose focus as the subject moves, especially if you are shooting in continuous mode at a high frame rate.

The third advantage to this type of focusing is that it's easy to focus and then recompose without having to worry that the camera will start to focus again when you press down on the shutter release button.

The downside to this focusing method is that you have to use two fingers—your thumb to access the focus button, and your forefinger to take the photo—which means you cannot adjust which focus point or points are active.

How Shutter Speed Controls Motion

The shutter speed controls how long the shutter is open, allowing light to reach the sensor. To get your subject tack sharp (a term used to describe an in-focus image), you need to make sure that the shutter opens and closes fast enough to freeze the action. The faster the subject is moving, the shorter the shutter speed needed to freeze the action. This gives you control over how things in motion are depicted in your images.

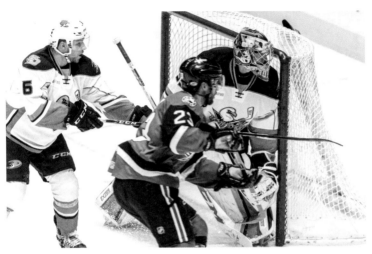

Figure 3.13 Back-button autofocus works great for situations like this, where I wanted to keep the focus on the goalie, but others (players and the referee) were skating in front of my subject. Being able to start and stop the focusing allowed me to continue taking photos of the goalie without the focus shifting to the players closer to the camera.

1/500 second; F/2.8; ISO 1600

Figure 3.14 Using back-button autofocus allowed me to keep the focus right on the ball.

1/500 second; F/2.8; ISO 3200

Freeze the Action Versus Show the Motion

The most important thing to work on when mastering how to show motion in your images is using a shutter speed fast enough to freeze the action so the subject of the photo is sharp and in focus (**Figure 3.15**). Once you are comfortable with freezing the action, then you can start working on slower shutter speeds that will cause intentional blur. You need to be careful that any blur in the image is intentional—not caused by using a too-slow shutter speed. Here are the minimum shutter speeds needed to freeze different types of action:

- People running or walking: 1/250 second
- Basketball, hockey, or soccer: 1/500 second (**Figure 3.16**)
- Cars driving: 1/500 sec – 1/2000 second
- Horses running: 1/1000 second
- Animals running: 1/1000second
- Person sitting still: 1/60 second
- Water: 1/1000 second

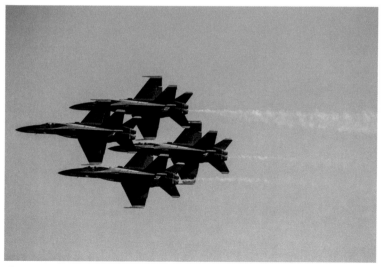

Figure 3.15 Freezing the jets took a shutter speed of 1/3200 second.
1/3200 second; F/6.3; ISO 800

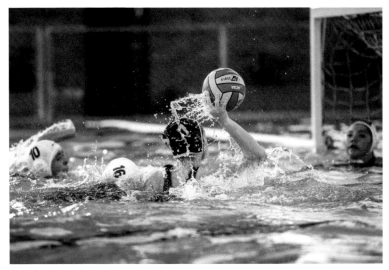

Figure 3.16 I used a shutter speed of 1/1000 second when photographing this water polo game to really freeze the action of the players and the water flying off the ball.

1/1000 second; F/2.8; ISO 3200

Please keep in mind that these are just rough guidelines. Some subjects move faster or slower than average, so they might need a faster or slower shutter speed to freeze the action.

How Low Can the Shutter Speed Go

Most cameras have a shutter speed range from 1/4000 second all the way to 30 seconds, but you can use even longer shutter speeds if you use the Bulb mode, which will allow you to keep the shutter open for as long as you like. So why would you want to purposely leave the shutter open to blur the moving items in your photos? This allows you to show the motion of the subjects in your image. You get to decide how much motion, from just a little—as seen in **Figure 3.17**, where the shutter speed of 1/6 second allowed the woman walking by the pub to be blurred, to **Figure 3.18**, where a shutter speed of 13 seconds allowed me to capture the light trails from the fireworks, to **Figure 3.19**, where a shutter speed of 30 seconds allowed the moving car lights to be rendered as solid white and red lines.

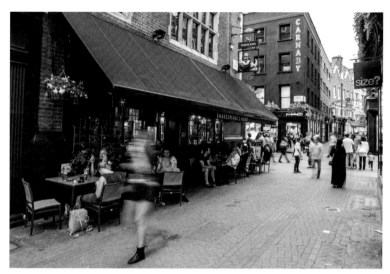

Figure 3.17 A shutter speed of 1/6 second gave enough time for the person in motion to be blurred, while those sitting or standing are in sharp focus.

1/6 second; F/4; ISO 200

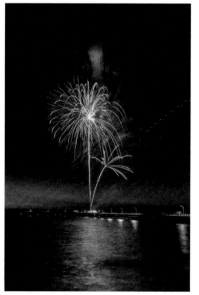

Figure 3.18 The Bulb setting allows me to open the shutter and keep it open for as long as is necessary for the shot. For this fireworks shot, I held the shutter open for 13 seconds while the fireworks lit the sky.

13 seconds; F/11; ISO 400

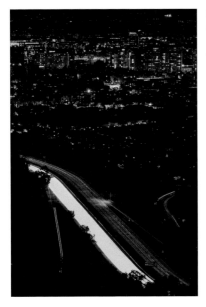

Figure 3.19 Achieving the light trails created by the cars driving at night required a 30-second exposure with the camera on a tripod. This technique renders the cars into solid light trails, but the buildings in the background are sharp and in focus.

30 seconds; F/6.3; ISO 100

Shutter speed is covered in more detail as it pertains to various subjects in later chapters.

Aperture and Depth of Field

The aperture setting controls the size of the opening in the lens, which controls how much light is allowed through the lens. The aperture also controls the depth of field, which determines how much of the scene in front of the camera is in focus when you take the photo. This is arguably the most important setting because it allows the photographer to determine what the viewer will actually be seeing. Our eyes are drawn to the in-focus areas in an image, so being able to determine what is in focus and what is out of focus is a very powerful creative tool.

The depth of field extends around the subject, including the 1/3 area in front of the subjects and the 2/3 area behind the subject (**Figure 3.20**). That entire area is the depth of field, and its range can be very shallow or very deep: it all depends on the aperture (and the focal length and distance between the camera and subject).

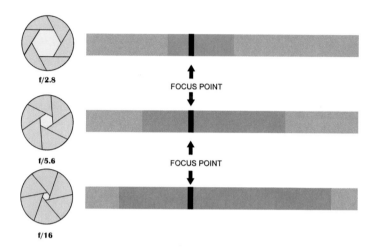

Figure 3.20 This is a simple diagram showing the depth-of-field relationship to the aperture.

Shallow Depth of Field

A shallow depth of field means a very small part of the image is in focus. The background is blurred so that the subject really pops, as you can see in **Figures 3.21** and **3.22**, where the wide-open aperture allowed me to capture the action and blur the background. You can see the performer is in sharp focus but the lights and stage in the background is out of focus, keeping the attention on the performer. You can also see how I isolated the snake's eye by blurring the rest of him and the background.

There are two downsides to using a shallow depth of field. The first is that it requires a lens that opens up really wide, which is more expensive (and usually heavier, bigger, and more bulky), and you have to be very careful that the focus is right on the subject. If it's even a little bit off, it can result in a blurred subject.

Figure 3.21 Photographing a performer on stage with a wide aperture of f/2.8 made the background blur and the subject stand out.

1/250 second; F/2.8; ISO 1600

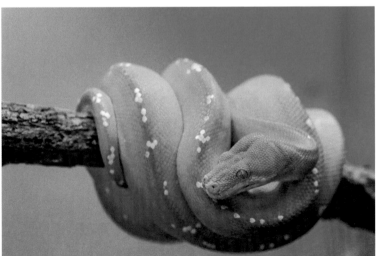

Figure 3.22 Using a very shallow depth of field, I was able to keep the eye of the snake in focus while the background and parts of the snake are pleasantly blurred.

1/125 second; F/1.8; ISO 800

Deep Depth of Field

At times you will want to have the whole scene, from the foreground to the background, in focus. This takes using a very small aperture to create a deep depth of field. This is useful when photographing landscapes and situations where you want everything in focus. In **Figure 3.23** I used an aperture of f/13 to keep the whole scene in focus. The downside of this is that with a very small aperture, you need bright light, a slow shutter speed, a high ISO. For this example, I used a shutter speed of 1/25 second and an ISO of 1600.

Figure 3.23 The train tracks and yellow painted line draw the eye into the photo. Since everything is in focus, the eye travels along the lines and out of the station.

1/25 second; F/13; ISO 1600

Distance and Focal Length

There are two other factors that play a role in the depth of field: the distance between the camera and the subject, and the focal length of the lens. The longer the focal length and the closer you are to the subject, the shallower the depth of field will be. The inverse is also true: if you want a deeper depth of field, use a shorter focal length and get some distance between you and the subject. This can be easily seen when shooting macro images, especially with a longer focal length like

the 105mm I used in **Figure 3.24**. By using a longer focal length and photographing very close to the subject, the depth of field is razor thin.

There is quite a bit of technical information that goes into this, but for the sake of practicality, the most essential aspect of this concept for your photography is knowing how to adjust and control the depth of field in your image.

Minimum Focusing Distance

Lenses have limitations—one of which being that they have a minimum focusing distance. The minimum focusing distance is the smallest distance between the lens and the subject where you can still get the subject in focus. Get closer than the minimum focusing distance and the lens won't be able to focus at all. This is one of the advantages that Macro lenses have over regular lenses: they have a very close minimum focusing distance, which allows you to get really close to your subjects.

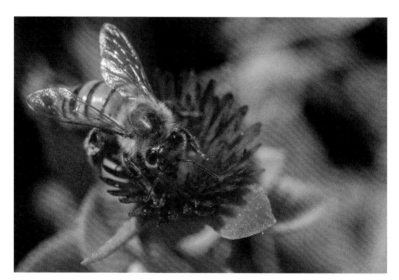

Figure 3.24 Using a 105mm macro lens allowed me to get up close and very personal with the bee. You can see that the depth of field is very shallow, even when using an aperture of f/11, due to the distance from the subject and the focal length used.

1/1000 second; F/11; ISO 1600

Distance-Limiting Switch

Many lenses have a distance-limiting switch that sets the distance that the lens will focus. This little switch can have a major impact on the performance of the autofocus by limiting the area the camera will focus on. It cuts down the time needed for the lens to focus because it won't try to focus from the minimum focusing distance to infinity. As you can see in **Figure 3.25**, the distance-limiting switch can be set to have the camera work the full range of available depth, or it can be limited from 5m (16.4 feet) to infinity.

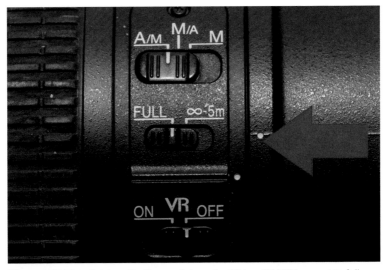

Figure 3.25 The distance-limiting switch on the Nikkor 70-200mm set to full.

Tripods Versus Handholding

There are two basic ways to support your camera when taking photos. The first is to hold it in your hands, and the second is to lock it down in a support like a tripod. The way you support your camera has an effect on the sharpness of your images. The camera will certainly be steadier when you use a tripod than it will be if you hold it in your hands.

The longer the exposure, the more critical it is to have the camera supported by the tripod so that it doesn't move during the exposure.

This means you can take those really long exposures without worrying about the camera moving. The downside to using a tripod is that you lose mobility, and unless you have a specialized gimbal tripod head, it is very difficult to track a moving subject. It also takes time to set up a tripod and you could miss the shot.

Here are some things to keep in mind about tripods:

- **Legs and Head:** There are lots of options when it comes to tripods because you can buy the legs and tripod head separately. That way you can get exactly what you want. I like to use a 3-way tripod head, so I have one of those on a set of tall tripod legs. I'm over 6 feet tall, so I need a tripod with long legs so I can use it comfortably. Make sure that your tripod can be set high enough for you to use comfortably.

- **Materials:** The materials that the tripod legs are made from can have a big effect on the weight and stability of the tripod after a while. Traditional wood tripod legs are very stable, but can weigh a lot. Some of the newer materials are really light and strong, but can also be expensive. When considering which tripod to purchase, make your selection with your usage in mind. If you do not need to carry your tripods to locations, you might not need to worry about the weight, whereas if you have to hike for miles before using the tripod, the weight and portability is most important.

- **Locking Mechanism:** The tripod legs have one of several different types of leg locks. Pick a type that is comfortable for you to use. The two main options are twist locks and lever locks. I like the lever locks because I use my tripod on the beach a lot, and they are easy to clean.

- **Weight:** You need to use a tripod that can support the combined weight of your camera and lens. A lightweight tripod might be more convenient for carrying around, but if it doesn't support your gear properly, it defeats the purpose of using it.

I usually do not set up a tripod unless I know I am going to be doing long exposures. Know, too, that there are times that a tripod is not allowed or it's impractical to use one. In these situations, you should be able to hold your camera steady to get the best results. When you handhold a camera, there are certain things to keep in mind for getting the sharpest images.

- **Minimum shutter speed:** There is a rule (more like a guideline) that photographers use to avoid camera shake, which is the small vibrations inside the camera that can make your images blurry. The guideline is to use a shutter speed that is at least 1/focal length. So, if you are using a 200mm lens, the slowest shutter speed you should use is 1/200 second. If you use a 60mm lens, the slowest shutter speed you should use is 1/60 second. This is just a baseline shutter speed to deal with camera shake—you still need to take into account the speed and movement of the subject.

- **Hold it steady:** The best method of holding your camera steady is to support it from the bottom and keep it close to your body. Make sure that the camera is as stable as possible and doesn't move when you take the photo. There is a technique I use (you can see it demonstrated by Joe McNally here on YouTube: https://www.youtube.com/watch?v=EDsx3-FWfwk) in which I turn my body sideways and use part of my shoulder to steady the camera. This allows me to get sharp images with slower shutter speeds (**Figure 3.26**).

- **Shoot a set of 3–5 images:** This is my favorite technique because it works really well and doesn't take any extra gear or special planning. Instead of taking a single photo, put the camera in continuous mode and take a burst of three photos. The chances are the middle photo will be the sharpest.

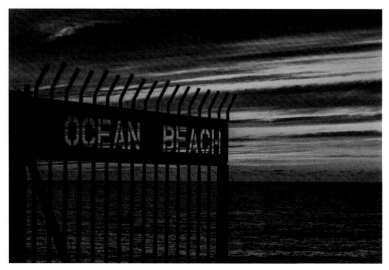

Figure 3.26 I did not have a tripod with me, but I really wanted to capture the amazing sunset. I steadied myself and took this image using a 1/15-second shutter speed using the Joe McNally method. It worked great.

1/15 second; F/5.6; ISO 400

Timers and Remotes

There is one more piece of equipment that will allow you to get the sharpest possible images, especially when using a tripod or other camera holder: a remote trigger or timer. There are two types of remotes, wireless and wired, and both do the same job. A remote trigger allows you to activate the shutter button without touching the camera (**Figure 3.27**), and you can set a timer to automatically trigger the shutter button after a set amount of time. In both cases, you do not have to worry about the camera shake caused by handholding the camera or pushing the shutter release button.

It doesn't matter what type of remote you use; it's just important to have a way to trigger the camera without actually touching it.

Figure 3.27 I use the Nikon MC-36 cable release to take long exposure photos. It allows me to trigger the shutter release and keep it open for as long as I want without touching the camera.

Making Sure Your Images Are Sharp

The screen on the back of your camera is great tool, if it is used correctly. It can also lie to you. The screen is small, so it is very difficult to tell if the photo is in focus unless you look at the image zoomed in to 100%. As you can see in **Figures 3.28** and **3.29**, the image looks like it is in focus when you look at the whole image on the camera's screen, but when you zoom in, you can see that the subject is not really in focus.

Every camera is a little different, but they all allow you to zoom in on the displayed image on the camera's screen. Some cameras allow you to set the zoom to 100% so you can check the image at full magnification with the push of a single button. Check your camera manual for how to set this on your camera—it makes it much easier to quickly check the focus of a shot.

Figure 3.28 Here, you can see how small the image actually looks on the back of the camera. It is impossible (at least for me) to see if the image is in proper focus at this size.

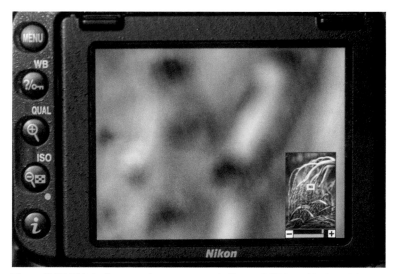

Figure 3.29 This is the same image as seen in Figure 3.28, but this time, it is zoomed in to a 100% view, and it's obvious that the image is not in focus at all.

PRACTICE

Give This a Try

Knowing your gear is important. Since I can't write about each and every camera available (that would be a very big and expensive book!), you are going to have to do a little work. Grab your camera manual and check out the section on Auto Focus. You will want to make sure you know how many AF points you have, how to switch the AF modes, and how to select the individual AF points on your camera.

Give This a Try

Test out the difference the aperture can make. Take a series of photos of the same subject in aperture priority mode, starting out with the widest aperture and going to the smallest aperture. When you check out the photos, you should see that the subject is in focus in the first image, but the area in front and behind the subject isn't. As the sequence progresses and the aperture gets smaller, more of the area around the subject comes into focus.

Take It a Step Further

Since the depth of field in a photo is so important, let's build on the aperture tests. Take a series of photos going through the apertures from biggest to smallest. Then, move the camera as close to the subject as possible while keeping it in focus and take the set of images again. See what difference the distance between the camera and the subject makes to the area that appears in focus. You can also do the same test but change the focal length for each set of images. This is the best way to see the effect the focal length has on the depth of field.

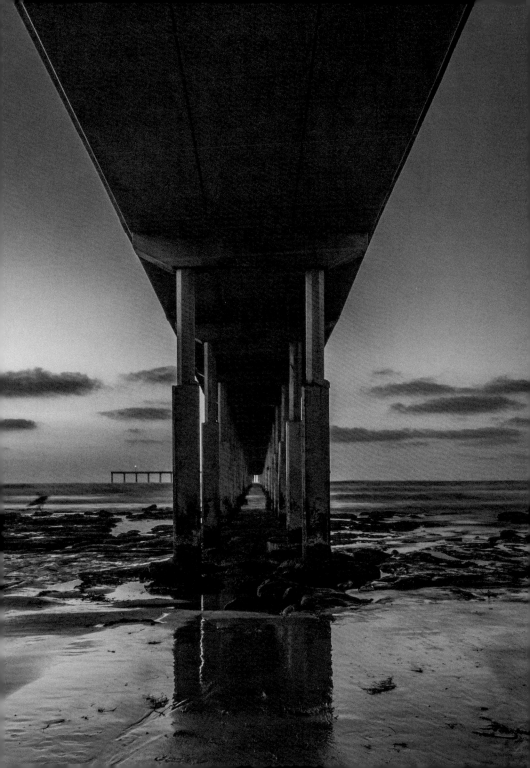

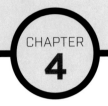

COMPOSITION

This chapter is all about the fun stuff, the creative aspect of photography aside from camera settings. Composition is all about what you decide to show in your photo and what you leave out. There are some technical aspects when it comes to lenses and apertures, but we will keep this as simple as possible with lots of examples. Let's start with the first compositional choice you make: which lens to use.

Lens Basics

When you see something that you want to photograph, one of the very first things to think about is which lens or focal length to use. Do you want to capture a wide vista or just a small part of the scene? Are you able to get closer to change your view or are you limited by where you can stand? Lenses come in a huge variety of focal lengths from the super wide 8mm to the extreme telephoto 800mm.

To understand which lens to use, you need an understanding of lenses in general. They are described using both the focal length (in millimeters) and the aperture (or aperture range). These two descriptors can tell you everything you need to know about a lens.

Focal Length

The focal length of a lens is defined as the distance from the optical center of the lens when it is focused at infinity to the camera's focal plane. A better way to think of it is the smaller the focal length number, the wider the view. The larger the focal length, the narrower the view (which gets you closer to the subject). The focal lens determines how much of the stuff in front of the camera is captured in the shot. This is described as the angle of view. **Figure 4.1** shows that the longer the focal length of the lens, the smaller amount of the scene is able to be captured.

Figure 4.1 This diagram shows the area in front of the camera that can be captured depending on the focal length of the lens.

For practical purposes, you can see how the scene is captured depending on the focal length of the lens in **Figures 4.2–4.7**. You can see that in each image, the camera is recording a smaller and smaller piece of scene. Each of these images was recorded on the same sensor; it's the smaller the angle of view that makes the subject appear closer to the camera.

Figure 4.2 The Brooklyn Bridge photographed at 24mm.

1/200 second; F/8; ISO 200

Figure 4.3 This image was shot from the same spot using 40mm.

1/200 second; F/8; ISO 200

Figure 4.4 At 75mm, you can start to make out the flag above the arches.

1/200 second; F/8; ISO 200

Figure 4.5 At 120mm, the flag is getting a little clearer and the middle-ground light in the previous shot is now closer.

1/200 second; F/8; ISO 200

Figure 4.6 At 200mm, the flag is much clearer and the lamp is nearly out of the frame.

1/200 second; F/8; ISO 200

Figure 4.7 At 300mm, the lamp is gone and the flag is clear.

1/200 second; F/8; ISO 200

You can break lenses down into three different groups of focal lengths: wide angle, normal, and telephoto.

- **Wide Angle:** These lenses capture the scenes that are wider than normal view. These are lenses with focal lengths smaller than 50mm on a full-frame sensor or 35mm on a cropped sensor. Wide-angle lenses can cause distortions with the perspective, making objects closer to the camera seem larger than other items in the scene. There can also be distortion on any subjects close to the edge of the frame, especially when using fisheye lenses.

- **Normal:** These lenses have a focal length of 50mm on a full frame or 35mm on a cropped frame camera. These focal lengths are called normal because they mimic the view of the human eye. These lenses capture the scene in the same way that you see it, without distortion.

- **Telephoto:** Telephoto lenses have focal lengths greater than the normal view. These lenses can get you in really close to your subject and are used by sports and wildlife photographers to capture those amazing close-up shots that happen far away from the photographer.

Prime Versus Zoom lenses

There are two types of lenses, those that have multiple focal lengths and those with a single focal length. The lenses with a single focal length are called prime lenses, while those with multiple focal lengths are called zoom lenses. There are some major differences between these two types of lenses, including size, weight, and cost. Let's look at the pros and cons of each:

Prime or Fixed Focal Length Lenses

These lenses have a single focal length, so if you want to change what they capture, you have to move. Instead of zooming in or out, you have to get closer or farther away from the subject. This can be limiting, since there are times when you can't move around. Many prime lenses can also be more expensive than a zoom lens counterpart, mainly due to the construction of the lens and the maximum aperture.

Prime lenses have one really big advantage over zoom lenses: they can have a greater maximum aperture. This allows prime lenses to be used more successfully in lower light, and they can have a much shallower depth of field than a zoom equivalent. The prime lenses can also be smaller and lighter than the zoom lenses. Many people believe that the prime lenses are sharper, and generally better than zoom lenses, though I can't see any image quality difference between good prime lenses and good zoom lenses. Take **Figures 4.8** and **4.9**: the first was taken with a 85mm f/1.4 lens, while the second was taken with a 70-200mm f/2.8 zoom lens. Both lenses are great, and the image quality of the two photos is comparable.

In all my years of taking photos, I have never had a bad lens. I have used lenses that cost more than a car to lenses that cost less than $100, and they all performed how I expected them to. I do think that it is worth spending more on a lens to get what you want, especially in terms of maximum aperture. I have owned some of my lenses for more than 20 years, and with cleanings and maintenance, I expect them to last for another 20 years.

Figure 4.8 I photographed Nicole using the 85mm f/1.4 Nikkor lens. The lens is great for portraits, and one of my favorites to use.

1/250 second; F/8; ISO 100

Figure 4.9 This shot of Nicole was also taken at about 85mm, but with the 70-200mm f/2.8 Nikkor.

1/250 second; F/8; ISO 100

Zoom Lenses

Zoom lenses cover a range of focal lengths, allowing you to change the view without having to actually move. When I started taking photos, most cameras came with a 50mm lens; now most cameras come with a zoom lens. These lenses are more convenient for most people because they allow one lens to do all the work instead of having to carry a whole set of prime lenses around. The manufacturing of zoom lenses has really improved over the years and now there are zoom lenses that are just as sharp as prime lenses. There are two types of zoom lenses, those with a constant maximum aperture through the full focal length range, and those where the maximum aperture changes as the focal length changes.

The real power of zoom lenses is the ability to shoot from the same spot and drastically change what you capture. They offer a versatility that is unmatched and really useful, especially when traveling or any time you don't want to take a bunch of lenses with you. Take, for example, a lens like the 15-300mm—which covers a massive focal length range. Look back at the Brooklyn Bridge photos (Figure

4.2–4.7). They were taken with the same camera and lens without me having to move at all. That is very useful, and it opens up a lot more options than using a prime lens.

Understanding Constant Aperture Versus Variable Aperture Lenses

There is another way to sort zoom lenses, and that is by what happens to the maximum aperture when you change focal lengths. There are two categories here: the first is lenses that maintain the maximum aperture throughout the focal length range (constant aperture); the second is lenses with a maximum aperture that changes depending on the focal length (variable aperture).

Let's take a look at two lenses and see the difference between them. For this example, I am going to use my favorite lens, the Nikkor 70-200mm f/2.8, and compare it to the Canon EF 100-400mm 4.5–5.6. Both of these lenses cover a wide range of focal lengths. The Nikkor covers from 70mm to 200mm, while the Canon covers 100mm to 400mm. The difference comes in when you look at the widest aperture available at those focal lengths. The Nikon has a constant aperture of f/2.8, which means that it can open to f/2.8 at 70mm and at 200mm and at every focal length between the two. The Canon lens has a maximum aperture of f/4.5 when it is used at 100mm; but when you zoom in and use the 400mm focal length, its maximum aperture is f/5.6. The maximum aperture is not constant throughout the focal length range. There are a lot of lenses like this; they tend to be less expensive.

Here is the important thing to know about these lenses. The exposure settings available at the widest focal length are different from the exposure settings available at the long end of the focal lengths. Let's look at an example using a variable aperture lens. With the camera set to aperture priority, and the aperture set wide open at f/3.5, and the focal length set to the widest at 24mm, I took the photo seen in **Figure 4.10**. Then, without changing any of the settings, I zoomed in to a focal length of 120mm and the camera automatically adjusted the aperture (to 5.6). Since there was less light reaching the sensor, the camera also adjusted the shutter speed to 1/100. You can see the resulting image in **Figure 4.11**.

Figure 4.10 The beach at sunset, shot with the 24-120mm f/3.5-5.6 Nikkor lens at 24mm.

1/320 second; F/3.5; ISO 3200

Figure 4.11 The same scene, but shot with a 120mm focal length. The aperture changed to f/5.6, which caused the shutter speed to drop to 1/100 second.

1/100 second; F/5.6; ISO 3200

As you can see, the smaller aperture created a slower shutter speed and caused a slight blur in the image. This was all done because the variable aperture lens changed the maximum aperture when you changed the focal length.

WHY SOME LENSES ARE SO EXPENSIVE

Go into any camera store and check out the lenses. Be prepared for some sticker shock! There is a reason that some lenses are so much more expensive than other lenses, even though they look pretty similar. The main reason is the maximum aperture of the lens. Take a look at these two lenses: the 400mm f/2.8 and the 300mm f/4, as seen in **Figure 4.12**. The 400mm f/2.8 lens costs over $10,000, while the 300mm f/4 costs about $1,200. That is a huge price difference. It is also a huge size and weight difference—those big heavy lenses are more expensive to make. The rule of thumb is that the wider the maximum aperture, the more expensive the lens. That wonderful shallow depth of field that you can get at f/2.8 (or wider) usually comes at a price.

Figure 4.12 It's easy to see which is the heavier, more expensive lens.

Lenses and Sensor Size

Digital cameras have a digital sensor that works like a piece of film to record your image. The sensor size can vary depending on the camera you have. There are two categories of sensors used in today's digital cameras, the full-size sensor and the cropped sensor. The full-size sensor is the same size as a 35mm piece of film, while the cropped sensor is smaller.

The focal length of the lens is based on a 35mm piece of film (36mm x 24mm), or a full-sized sensor. Those same lenses can be used on a cropped sensor, but the effective focal length will be greater depending on the cropped sensor size. There are a couple of different sensor sizes when it comes to the cropped sensors. The Nikon and Sony cameras use a DX sensor size, which is 24mm x 16mm, and the Canon cameras use a slightly smaller 22.2mm x 14.8mm size. You can see the difference in what they capture in **Figure 4.13**.

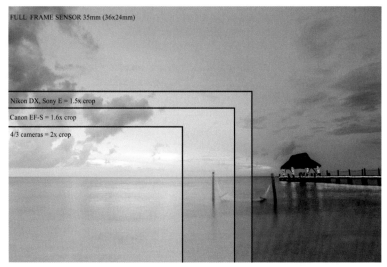

Figure 4.13 Here, you can see the full-frame sensor and the relative sizes of the cropped sensors.

When you use a lens on the cropped sensor cameras, the effective focal length is greater than the lens focal length. This is because the small sensor is cropping the edges of the frame in the camera. There is a whole series of lenses that were created especially for the cropped sensor cameras. These tend to be cheaper than the full-frame counterparts, but they can only be used on the cropped frame cameras (**Figure 4.14**). To determine the focal-length equivalent, multiply the current focal length by either 1.5x (for the Nikon and Sony cropped sensors) or 1.6x (for the Canon cropped sensors). For example, if you are using the 50mm lens on the Nikon or Sony cropped sensor cameras, the effective focal length is 75mm (50 x 1.5 = 75).

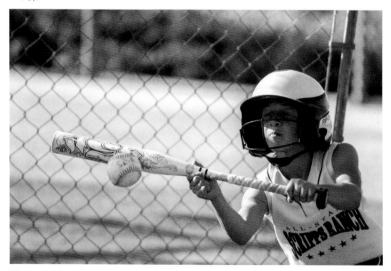

Figure 4.14 I used the 70-200mm lens at 200mm on a cropped sensor camera, which was an effective 300mm focal length that allowed me to get in really close during this softball practice.

1/2000 second; F/2.8; ISO 400

How Focal Length Affects Your image

A little earlier in the chapter, I talked about focal length in terms of how much of the scene in front of the camera is captured, but there is a more subtle effect that the focal length will have on your image. This effect is called compression and it describes how the things in the foreground interact with things in the background. The longer the focal length, the more compression there is; the shorter the focal length, the less compression there is. The easiest way to see this is to look at **Figures 4.15–4.18** to see how the subject and the background change with the focal length used.

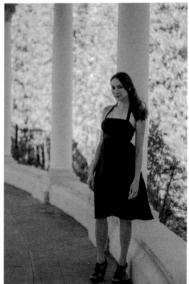

Figure 4.15 Photographed at 24mm focal length.

1/800 second; F/2.8; ISO 200

Figure 4.16 Photographed at 70mm focal length.

1/800 second; F/2.8; ISO 200

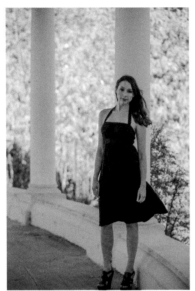

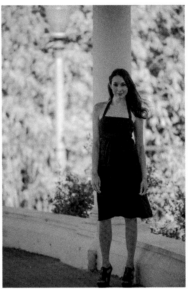

Figure 4.17 Photographed at 105mm focal length.

1/800 second; F/2.8; ISO 200

Figure 4.18 Photographed at 200mm focal length.

1/800 second; F/2.8; ISO 200

WHY I LOVE THE 50MM F/1.8

If you want to experiment with shallow depth of field, I really recommend buying or renting a 50mm f/1.8 lens. These are inexpensive and can really help your experimentation with a shallow depth of field. The Nikkor 50mm f/1.8 (**Figure 4.19**) and the Canon 50mm f/1.8 both cost less than $150, making them a bargain. The best part about these lenses is the ability to shoot at f/1.8—which is really wide, and allows for a very shallow depth of field. **Figures 4.20** and **4.21** show the same scene shot at f/1.8 and f/16.

Figure 4.19 My Nikkor 50mm f/1.8 lens has seen a lot of use.

Figure 4.20 Shot at f/1.8, this photo features is a very shallow depth of field. The focus was right in the middle of my zucchini, and as you can see, the garden shears right behind them are out of focus.

1/1250 second; F/1.8; ISO 400

Figure 4.21 At F/16, everything is in acceptable focus, from the bark in front to the mint in the background.

1/15 second; F/16; ISO 400

Lens Descriptions Demystified

Buying a camera lens is a big deal, and a lot of fun. A new lens can open up a whole different aspect to your photography, or just help you capture the scene in front of your camera the way you always wanted. But the process can be confusing, especially when it comes to all those crazy numbers and letters in the lens description. I'll cover the basics here so you have a better idea of what they all mean. The two most important descriptors are the focal length (focal-length range) and the maximum aperture (maximum aperture range). The good news is that they are the easiest to see and decipher on a lens. The whole number (or numbers) is the focal length in mm. You might see that some lenses have the mm after the length, but others do not. As you can see in **Figure 4.22**, the focal length of this lens is 85mm. The maximum aperture is shown as a fraction of 1:1.4, which translates to f/1.4. In **Figure 4.23**, you can see that this lens has a range of focal lengths from 18mm–55mm, and instead of a single maximum aperture, it has a range of maximum apertures from f/3.5 at 18mm to f/5.6 at 55mm.

Figure 4.22 The Nikkor 85mm f/1.4 lens.

Figure 4.23 The Nikkor 18-55mm f/3.5–5.6 DX lens. The DX means this lens was made for the cropped frame cameras and won't use the full sensor if it is used on a full-frame camera.

Here are some of the other lens descriptors used by Nikon, Sony, and Canon.

NIKON

- **DX:** This stands for cropped frame sensors.

- **AF (Auto Focus):** Many times there is another letter after the AF that designates the type of autofocus.

- **VR / VRII:** The lens has a vibration reduction built in.

- **G:** This means that the lens does not have an aperture ring.

SONY

- **DT (Digital Technology):** These lenses are designed for the Sony cropped sensor cameras.

- **G:** This designates the lens as a Gold lens, the top of the Sony line.

- **SSM:** A supersonic Motor for focusing is built into the lens.

CANON

- **EF:** These lenses can be used on all full-frame and cropped sensor cameras.

- **EF-S:** These lenses are designed for the smaller Canon cropped sensor and should not be used on the full-frame cameras. The rear element of the lens may get hit by the mirror on the full-frame cameras.

- **L:** This stands for Luxury on the Canon high-end lenses.

Composition

The composition of your images (what you decide to leave in the image and where you decide to place it in the frame) makes them uniquely yours. After you have made the lens (or focal length) choice, it is up to you to figure out what the photo is going to be.

Where to Place the Subject, and Why

There are some compositional rules that I'm sure you know and may have even tried. Here are some guidelines and how I have used them to strengthen my compositions. We will start with the most often-quoted, the rule of thirds.

The Rule of Thirds

The rule of thirds might be the most talked about compositional "rule" in photography, and for good reason: it helps people get better images, it's really easy to understand and implement, and once you understand what the rule does, you can choose to ignore it. The rule of thirds is where you divide the scene with two parallel vertical lines and two parallel horizontal lines to create nine equal sections, and you place the important elements of your composition where the lines intersect (**Figure 4.24**).

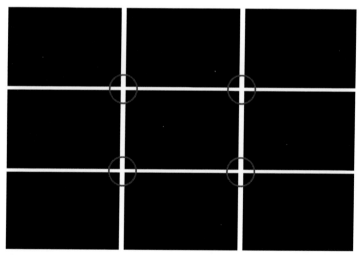

Figure 4.24 The rule-of-thirds grid. The important elements of the photo should be placed where the lines intersect.

I have been using, or at least thinking about, the rule of thirds for many years now. It has become part of my process when I look through the viewfinder. My first thought is to place the important elements of the photo to align with one of the four intersection points. **Figures 4.25–4.30** use the rule of thirds, as you can see with the graphic overlay.

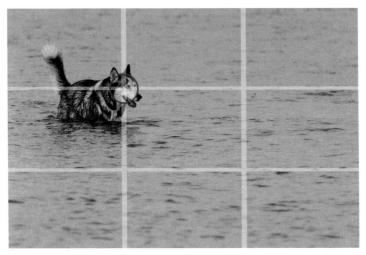

Figure 4.25 The dog was out playing in the water, so I placed him in the top-left corner of the composition, which not only used the rule of thirds, but also gave him space to move in the frame.

1/2500 second; F/2.8; ISO 1600

Figure 4.26 I spotted this flamingo with the one eye visible at the zoo. I used the rule of thirds to keep the eye in the top-right grid intersection. Since the head was facing to the left, this was the most natural placement within the frame.

1/250 second; F/5.6; ISO 800

Figure 4.27 In the London underground, there are some great graphic elements that I used in this image. I placed the Exit sign at the upper-right grid intersection, which creates a more balanced image.

1/60 second; F/5.6; ISO 1600

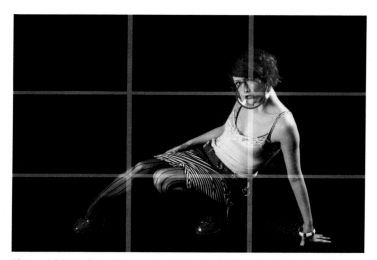

Figure 4.28 My friend May posing in the studio. The rule of thirds worked well for this photo because her face was in the top-right grid intersection, and her body position also mimicked the vertical and horizontal lines.

1/60 second; F/6.3; ISO 800

Figure 4.29 I photographed this from the top of St. Paul's Cathedral in London. The rule of thirds helped me with the placement of the tower to create a more pleasing image.

1/250 second; F/4; ISO 800

Figure 4.30 When photographing people and animals, a good practice is to place one of the intersecting points over the eye.

1/250 second; F/5.6; ISO 400

The Horizon

The rule of thirds can also be used to create a stronger landscape image because it can show you where to place the horizon. The easy rule is that the horizon should be either 1/3 from the top or the bottom of the composition, and you make that decision based on which is more interesting: the sky or the ground. If the sky is more interesting, then the horizon should be 1/3 from the bottom, giving more of the frame over to the interesting sky (**Figure 4.31**). If the ground is more interesting, then more of the frame needs to show that, so the horizon is 1/3 the way from the top (**Figure 4.32**).

Dead Center

When I first picked up a camera, there was no autofocus. You needed to turn the focusing ring on the lens until the image was in focus. Cameras used a split screen: in the center of the frame, the image was spilt, and when the two halves of the image aligned, the subject is in focus. The downside to this was that for many years, even after autofocus was introduced, I kept placing the subject of the photo right in the middle of the frame. There isn't anything wrong with this, but it can be a little boring.

There are times when placing the subject in the middle of the frame can really work, especially when it gives the subject some impact. When you do this, try to make sure that the image looks symmetrical and balanced (**Figures 4.33** and **4.34**).

Figure 4.31 The pier and the clouds made me place the horizon line 1/3 in from the bottom of the frame so most of the composition would show the structures against the sky.

1/30 second; F/16; ISO 200

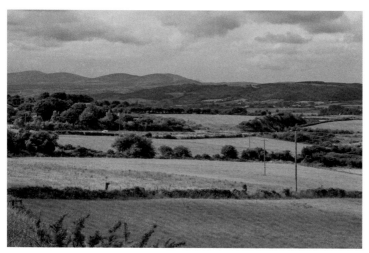

Figure 4.32 In Ireland, the hills are an amazing green. Here, the horizon line is 1/3 from the top of the frame, allowing more room to show the land.

1/250 second; F/11; ISO 400

Figure 4.33 The British have great door knockers. This image was taken with the subject directly in the middle of the frame, and there can be no doubt what the image is about.

1/125 second; F/5.6; ISO 800

Figure 4.34 At times, the horizon line can go right through the center of the frame. Here, it works well to showcase the symmetry of the pier.

1/400 second; F/2.8; ISO 600

Fill the Frame

Filling the frame means getting close to your subject and having it fill most of the photo. (Try to avoid leaving unimportant information in your photograph—it can be distracting and may reduce the effectiveness of the image.) This is particularly useful when shooting sports. In **Figure 4.35**, I used a 400mm f/28 lens to get as close to the action as possible to fill the frame. You can see the player with the ball, the players trying to steal the ball, and nothing else.

Figure 4.35 Trying to avoid a tackle during the Poinsettia Bowl. The frame is filled with the action and it's obvious where to look and what the subject is.

1/1600 second; F/2.8; ISO 3200

This compositional guide is especially useful for folks sharing photos on social media and for photos viewed on smartphones and tablets. The small screen and most people's short attention span means that people don't spend a lot of time looking at each photo, so you need to make sure that people can see the subject and don't get distracted by anything else in the frame (**Figure 4.36**).

Figure 4.36 A panda at the zoo. I filled the frame, and was still able use the rule of thirds to place the important parts at intersection points on the rule-of-thirds grid.

1/250 second; F/4; ISO 600

Space to Move

Leaving some space for your subject to move in the frame makes your photographs look more natural. This is particularly true if the subject is moving when you photograph it. Take the dog running on the beach in **Figure 4.37**. By having more space in front of the dog and less behind it looks more natural. This is also true when you have a person (or animal) looking to the left or right: leave space where the subject is looking so they don't look like they're staring out of the frame (**Figure 4.38**).

Figure 4.37 I love photographing dogs running on the beach. Their sheer joy and excitement is great to capture. Giving them a little space to move makes for a better composition.

1/800 second; F/2.8; ISO 3200

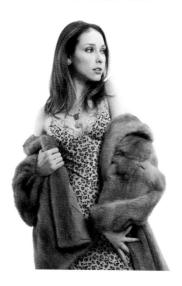

Figure 4.38 When I photographed Mia, I kept her to the left in the frame and had her look to my right. This gave some space for her to look out, making the image look less crowded.

1/250 second; F/8; ISO 100

The opposite of having space to move is when the action butts right up against the edge of the frame. This can make the viewer feel uncomfortable for no good reason because it heightens the tension in the photo. Once you see how the subject having space to move works, consider trying a shot where the subject is right up against the edge of the frame, like the surfer in **Figure 4.39**.

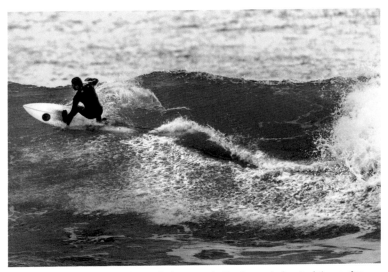

Figure 4.39 I purposely left very little space in the frame in front of the surfer and lots behind to heighten the tension in the image.

1/3200 second; F/4; ISO 1600

Diagonals

Leading lines draw the viewer's eye from the edge of the image into the photo. The diagonal leading lines come from the edges, usually close to the bottom or top corner. The eye follows the lines and is naturally drawn from the edge of the image to the subject. Just about anything can be used to create the line—all it has to do is catch and direct the eye. In **Figure 4.40**, the leaf edge makes for a great diagonal leading line, along with the legs and body of the butterfly. These factors draw the eye into the photo and toward the butterfly.

Figure 4.40 Look for anything that is pointing into the image from an edge, like this leaf the butterfly is standing on. It draws the eye from the bottom-right corner into the photo.

1/800 second; F/3.2; ISO 800

Odd or Even

When I first heard of this compositional trick, I thought it was rather odd, but it really does work. The idea behind this is that an odd number of subjects is better than an even number of subjects. If you have an even number of subjects, the brain tends to have a hard time deciding which of the subjects they should be concentrating on. Having an odd number of subjects can make the composition more balanced and interesting.

This doesn't work in all situations. If you have 10 or 11 subjects, viewers might not notice the difference between even and odd subjects, but with fewer subjects, considering even and odd subjects is a great way to start to frame your shots. Down at the beach I noticed the three bikes parked on the walkway, but before I could take a photo, one of the bikes got a rider. However, I really liked the symmetry of the odd number of subjects (**Figure 4.41**).

Figure 4.41 The three bikes stood out to me, but right before I could take a photo, a rider climbed onto one of the bikes.

1/125 second; F/5.6; ISO 1600

Frame Within a Frame

One of my favorite compositional techniques is to frame the subject of a photo with a framing structure within the photo. This could be photographing through a window or arch, as seen in **Figure 4.42**, or using a graphic element in the scene to frame the subjects, as seen in **Figure 4.43**.

The other side of this compositional coin is to make sure that there is nothing coming in from the edges that distracts or draws the attention away from the subject. In **Figure 4.44**, there is nothing around the statue at all.

Figure 4.42 Walking the streets of London, I noticed the arches over the streets, which did a great job of framing the building in the background.

1/125 second; F/5.6; ISO 200

Figure 4.43 When Nicole and Glenn posed for engagement photos at a local winery, the door made a great frame for the couple.

1/125 second; F/4; ISO 200

Figure 4.44 The statue of Queen Anne outside of St Paul's Cathedral is photographed all day, so I looked for a different angle to get a unique photo. 1/640 second; F/5.6; ISO 400

Landscape Versus Portrait Orientation

This is a simple choice. Do you take the photo in landscape or portrait orientation? It all depends on the subject, and in many cases, the use of the image. I take photos for a large event venue in San Diego, and many times the images I take are used in the venue for promotional purposes. These images need to be taken in landscape orientation because of the spaces they will fill. However, if you're not making photos that need to fit in a specific format, the best way to choose the orientation of your shot is to look through the viewfinder and see what looks better to your eye.

Which of these two photos (**Figures 4.45** and **4.46**) do you like better? This scene is the same in both, but I think Figure 4.46, with the road running down the hill, is a better way to frame the scene.

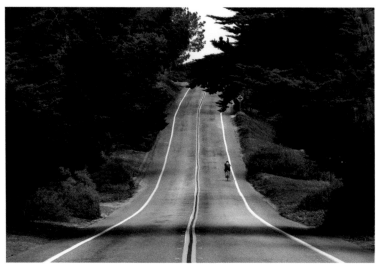

Figure 4.45 The road to Cabrillo National Monument is a favorite for hard-core bicyclists (and photographers).

1/250 second; F/11; ISO 200

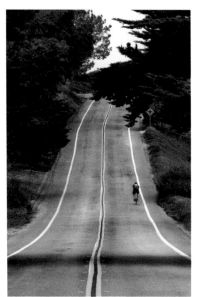

Figure 4.46 In this version of the photo, the road is more prominent because it takes up more space in the frame.

1/250 second; F/11; ISO 200

If you're not sure which way to take the photo, try both. Many times I will take both a portrait shot and a landscape shot.

Using Color Versus Black-and-White

Playing with having both color and black-and-white photos is so much easier to do with digital cameras because they allow you to have both color and black-and-white images from the same file. In the days of film, you had to decide between color and black-and-white when you put the film in the camera. Now you can decide if the photo looks better in full color or black-and-white later when you're post-processing.

Here are a couple of things to think about when deciding between black-and-white and color.

- **Color Impact:** Is the color important to the photo? If you remove the color, would the impact of the photo be diminished? Is the color one of the main subjects?

- **Tones:** Are the tones in the image more important than the color? Is the color distracting from the main subject?

- **Texture:** Do you want the viewer to see the textures more clearly? Are the colors showing or hiding the textures in the image?

- **Bad color:** Are there unpleasing hues in the image? Will the removal of the color result in a better photo?

Many times I get what I consider bad color in images from mixed lighting (or bad lighting). When I shoot concerts in bad lighting, I usually convert to black-and-white, which can save an otherwise ugly photo (**Figure 4.47**).

For **Figure 4.48**, I liked the tone and mood created by turning this scene to black-and-white. When I saw the brightly lit shop window and the shoppers walking up the street, there was very little color in the scene. Converting the image to black-and-white removed any of the distracting tones present and made for a stronger image. In the end, it is up to you to decide if you want the image to be full of vibrant color, subtler color tones, or to be in black-and-white.

Figure 4.47 When my buddy Mark Karan played a local gig, the light wasn't that great, so I converted this shot of him to black-and-white.

1/400 second; F/2.8; ISO 2500

Figure 4.48 Bright shop windows make for an interesting backdrop. This shot worked better in black-and-white than it did in color. It was shot at night and the light in the window looked white, so this image was close to being black-and-white already. Removing the final bits of color removed any distractions and made for a stronger image.

1/30 second; F/4; ISO 1600

The Background

One final compositional tip to go over is considering the background of your image. It's very easy to overlook items in the background that can have a negative effect on your images. I can't tell you how many times I have come home from photographing something, only to see things in the background that are really distracting that I didn't even notice when I was out taking the photo because I was so focused on the subject. Take a second or two to look behind the subject to see how the background is going to affect the subject and the foreground. Can you move to the left or right (or crouch or stand on something for a higher angle) to change the interaction between the subject and the background? For me, the background needs to help the story you are trying to tell—or at the very least, not distract from it.

I'll finish this chapter with a couple of examples of how backgrounds can change everything, from the very obvious to the more subtle. The first examples are two pictures I took while photographing a music festival. The difference between the two images is about 30 seconds, the time it took for the guitar player to walk toward me. You can see the huge difference that time made in **Figure 4.49** compared to **Figure 4.50**. A little patience can go a long way in improving your images. In **Figures 4.51** and **4.52**, you can see the same concept applied in an everyday situation with a man and his dog walking through my shot. It made a huge difference in the photo to wait until the background was clear of distractions.

If it is impossible to move or remove the items in the background (like the houses in Figure 4.52), I shoot with a wide aperture and use a shallow depth of field to try and blur the background so it isn't as noticeable (**Figures 4.53** and **4.54**).

Figure 4.49 The background in this image is very distracting and it draws the eye away from the guitar player.

1/400 second; F/2.8; ISO 640

Figure 4.50 Waiting just a few moments for the guitar player to walk in front of the stack of amps made for a much better background that doesn't distract the viewer's eye from the subject.

1/400 second; F/2.8; ISO 640

Figure 4.51 Paying attention to the background can make a huge difference in the final photo. Here, the man walking his dog makes the background busy and distracting.

1/500 second; F/4.0; ISO 500

Figure 4.52 A few seconds later the man and his dog had moved on, and the subject of the photo didn't have to compete for the viewer's eye.

1/500 second; F/4.0; ISO 500

Figure 4.53 When photographing a kids' sporting event, you can't always pick the background, but I try to minimize it by using a wide aperture—which also allows me to get a very fast shutter speed.

1/1600 second; F/2.8; ISO 200

Figure 4.54 When I photographed Chris playing at a concert, I had no control over the background. I used an aperture of f/2.8 to try and blur it as much as possible, which worked quite well. You can see the people in the background, but the focus stays on the musician.

1/1500 second; F/2.8; ISO 200

PRACTICE

Give This a Try

Understanding how the focal length can affect your image, especially the relationship of the subject to the background, can be tough to grasp. To help you understand this concept, take two images of a willing assistant, the first with a wide-angle lens as close to the subject as possible, the second with a telephoto lens from a good distance away. Try to keep the person the same size in each photo. Then check out how the different focal lengths affect the look of the photo.

Give This a Try

You don't even need your camera for this one! Make the effort to consciously look around throughout your day, anywhere, anytime. The idea is to train your eye to better see elements of photographic composition, including using the rule of thirds and incorporating diagonals. Take a look at the area in front of you: What subject pops out, where would you place it in the frame, what lens would best suit the shot, and what orientation should you hold the camera in? Ask these questions all the time as you go through your day, and when you are holding a camera, the process will start to feel really natural.

Take It a Step Further

Look to combine two compositional methods in the same photo. For example, use both the rule of thirds and diagonals in the same photo. Look for a subject that can be placed in one of the four intersections created by the rule of thirds and look for a diagonal that will lead the eye to the subject. It isn't easy, but it will help you recognize those elements that will help your composition.

TRAVEL PHOTOGRAPHY

I love to go to new places and see new things. I grew up in South Africa and moved to California in 1980. I spent my college years in Oregon, and have traveled to numerous places for both work and vacations. Taking photos of my travels allows me to remember a trip in a way that wouldn't be possible without the photos. Travel photography includes several different types of photography: you get to take portraits of people, shoot still lifes of the food, capture some landscapes, do some street photography, and even some architectural photography.

What Does It Take to Make a Great Travel Shot

Travel photography covers a wide range of subjects, including the local people, food, architecture, and landscapes. It also covers just about everything else that helps you tell the story of your travels. The best travel photos bring back the emotions you felt during your travels when you see the image. Here are some ideas to consider when looking for meaningful shots.

- **The reason for the visit:** What made you travel in the first place? Was it to sit on the beach and relax (**Figure 5.1**), or get out and see a new city (**Figure 5.2**)? Capture the reason for the visit and the photo will always mean something to you.

- **Think about postcards:** I love looking at postcards. I used to send them to friends and relatives when I traveled—before email, Instagram, and Facebook made sharing our vacation photos so easy. A postcard was a professionally taken photograph meant to show the subject (the place) in the best possible way, so looking at postcards can offer inspiration on how to best capture your location. In **Figure 5.3**, I wanted to show the beautiful green of the Irish countryside.

- **Tell a story:** What is the story that you are trying to tell in your images? Did you want to show people what you did, or are you trying to show where you are? In **Figure 5.4**, I tried to capture some of the scenes I witnessed at Speakers' Corner in Hyde Park in London, where public speaking and debates are allowed (and encouraged).

Figure 5.1 There's nothing quite like relaxing on the beach. I used a pretty fast shutter speed (1/80 second) because this shot was taken without a tripod and I wanted to make sure there was no blur.

1/80 second; F/5.0; ISO 500

Figure 5.2 The tall buildings of New York City, shot while wandering through the streets.

1/160 second; F/10; ISO 100

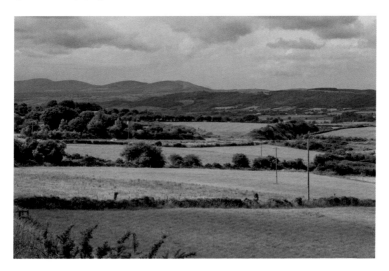

Figure 5.3 The green hills of Ireland, photographed from the side of the road while driving through the countryside. I took the time to stop and take the photo because I knew I would never be back there again.

1/320 second; F/16; ISO 200

Figure 5.4 Speakers' Corner in Hyde Park is a great place to people watch.
1/320 second; F/4; ISO 800

To prepare for great shots of your travels, before leaving for your trip
or even picking up your camera, do your research. You picked the
location for your trip for a reason. Is it the history of the area or the lure
of a relaxing beach? Whatever the reason is, make sure it's a focus of
your images. Research helps you discover interesting places or events
in your destination that you can incorporate into your trip for photo
opportunities. Start on the web, where there are numerous websites
dedicated to all kinds of travel. Other great resources are libraries,
bookstores, and friends who've already visited your destination. The
more information you have before you go, the more likely you are to
come away with interesting photos.

Once you're traveling and shooting, keep these guidelines in mind:

- **Keep your camera out:** Having your camera in a travel camera
 bag is great, but it takes time to get it out and get it ready to use.
 All that time means missed opportunities. Make sure the batteries
 are fully charged, that there is ample space on your memory card,
 and that you have extra cards on hand.

- **Stay safe:** I cannot stress this one enough. You need to be aware of your surroundings. Not only is that how you see possible photo opportunities, but it's also how you stay safe while wandering around a new place.

- **Plan time for photography:** Vacations can be a busy time trying to fit everything you want to do into a small amount of time. Unless you actually plan for some photo-taking time, your photography will be rushed. Making better photos takes time and energy, and rushing around at the last minute trying to get it all done guarantees that you will be disappointed in the results. Here is the hard part: usually the best light is early in the morning and late in the afternoon. Getting up early to go out and take photos is a great idea, but it does mean that you can't sleep in.

- **Look for other angles:** It's rare that the first photo you take is the best one. It's best to look for different angles and views of the subject before moving on to other shots. Does a change in the focal length or using a different aperture change the story that you are trying to tell? How about simply changing from landscape to portrait orientation? Use the different focal lengths to get different photos of the same scene. In **Figures 5.5** and **5.6**, you can see the difference between shooting a scene with a wide-angle lens (20mm) and a telephoto lens (200mm).

- **Tours:** Consider taking a photo-specific tour, especially if you're in a place known for photography. There are photo tours available in just about every location on the planet.

- **Photograph like you will never be back:** Take all the photos you might want on this visit because you might never be back! Even if you do come back, the light and situation will be different. Never say to yourself, "I'll photograph that next time." When I saw the young man sitting on the bench in the late afternoon (**Figure 5.7**), I didn't hesitate to take the photo, knowing I would never have this opportunity again.

Figure 5.5 This crowd was trying to take photos of the Queen's Guard in London. Using this 20mm focal length might have captured the overall scene, but didn't make a great photo.

1/1600 second; F/4.0; ISO 100

Figure 5.6 Moving in closer and zooming in to 200mm allowed me to eliminate all the people around the mounted guard from the shot.

1/800 second; F/4.0; ISO 200

- **Practice at home:** Everyone lives in a place that other people come and visit. Pretend you are a visitor to your hometown and go out and play tourist for a day. I know that nothing will seem new and exciting (at least for a while), but try to photograph what visitors would. Go to the beach, or the mountains, or the zoo, or a museum, or even a cheesy tourist attraction and try to come away with photos that would make people want to come visit. **Figure 5.8** was taken just down the street from my house at the beach during sunset. San Diego really is quite beautiful.

Figure 5.7 Wandering around Hyde Park, I saw this scene in front of me and stopped. I had my camera ready, composed the photo, and took it knowing this would be my only chance.

1/200 second; F/4.0; ISO 400

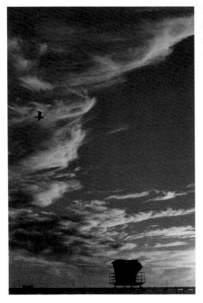

Figure 5.8 Living in San Diego is a blessing, especially when you get sunsets like this.

1/500 second; F/16; ISO 800

Getting Started

- **Exposure Mode:** Aperture Priority. Using this mode allows you to control the depth of field and make sure the subject is in focus. When taking travel photos, I often set the camera to exposure bracketing so that I don't have to worry about getting the exposure perfect while out exploring.

- **Drive Mode:** Continuous Drive Mode. This mode lets you keep taking photos as long as you hold the shutter release button down. I like this mode, especially when bracketing the exposure, because it allows me to take three photos in quick succession by just pressing and holding the shutter release button down.

- **Focus Mode:** Continuous Auto-Focus. In this mode, the camera keeps trying to focus as long as the shutter release button is pressed halfway down.

- **Focus Points:** Single Point, Center. I routinely use the single autofocus point in the center of the frame. Once I see a scene

I want to capture, I move the focus point depending on the composition.

The Critical Choices

- **Lens choice:** There are some great lens options for travel photographers. A great example is the Nikkor 28-300mm f/3.5-5.6 VR lens, which gives you a staggering focal range from 28mm all the way to 300mm on the full-frame camera. There are also great options for cropped-sensor cameras like the Nikkor 18-300mm f/3.5-6.3 DX lens, which covers an even greater range (but is just for use with the smaller, cropped sensors) (**Figure 5.9**). There are also options from lens companies like Tamron, which makes an 18-400mm f/3.5-6.3 lens for both Nikon and Canon cropped-sensor cameras (**Figure 5.10**), These zoom lenses can cover a huge focal length range, allowing you to shoot wide shots and zoom in close without changing lenses.

- **Know your metering mode:** Picking the best metering mode for the situation is important. Remember that large parts of very bright light or large parts of deep shadow may result in under- or overexposed photos. For these situations, use spot metering and make sure the spot is over a part in the scene that is roughly 18% gray. If you're not sure what 18% gray looks like, try to make sure the focus point and the spot metering point are over the most important thing in the frame, and then check the monitor on the camera to see if the shot is too light or dark (**Figure 5.11**).

- **Use exposure compensation:** Use the monitor on the back of the camera to check the exposure after you take the shot, and then adjust with the exposure compensation if needed (**Figure 5.12**). Dial in positive numbers to lighten the scene and negative numbers to darken the scene.

Figure 5.9 The Nikkor 18-300mm DX lens is a great option for travel photographers because it covers a wide range of focal lengths and is light and compact (photo courtesy of Nikon).

Figure 5.10 The Tamron 18-400mm f/3.5–6.3 lens covers a stunning range of focal lengths for a cropped-frame sensor and can be purchased for either a Nikon or Canon mount.

Figure 5.11 The camera gave me this exposure using matrix metering with the focus point right on Big Ben.

1/400 second; F/16; ISO 200

Figure 5.12 I thought this shot looked a little light, so I took the shot again using an exposure compensation of +.3, which gave me a slower shutter speed and a slightly darker photo.

1/320 second; F/16; ISO 200

CASE STUDIES

People

Lens: I like to photograph people with a longer focal length because it allows me to fill the frame and minimize the background. Because I usually use a zoom lens when traveling, I start out wide and zoom in until I feel the composition is best. Many of my images of people are taken closer to the 200mm focal length.

Exposure Settings: I shoot in aperture priority mode so I can control the depth of field. If the shutter speed gets too low to get a sharp image, I increase the ISO.

Where to Photograph: You can take photos of people anywhere there are people.

Tips

- **Ask permission:** I will be the first to admit that this is tough to do sometimes. Few people like going up to complete strangers and asking for something. There are some ways to make this easier:
 - Buy something first. It's much easier to ask someone if you can take their photo if you have just purchased something from them. A little commerce goes a long way.
 - Discuss price first. If you are shooting in a tourist area, it is possible that the person will want to be paid for allowing you to take their photo. Negotiate up front about these costs so you can make an informed decision.
 - Never photograph kids without their parents' or guardian's permission.

- **Look for street performers and shows:** Some of my favorite travel images are of street performers. I came across this performer in **Figure 5.13** on the streets of London. He made a fantastic subject. The performer in **Figure 5.14** was part of a show that the hotel put on for their guests. These type of situations are usually quite easy to photograph because they last for a while.

- **Share your images:** When it comes to photographing street performers, I always try to get their contact information and send them a couple of the images I took.

Figure 5.13 The most heavy-metal guy ever. Photographed on the streets in London, he was putting on a one-man show. I used a wide aperture to get a shallow depth of field to make him stand out against the background.

1/500 second; F/2.8; ISO 400

Figure 5.14 This man was throwing the fire from hand to hand during a show put on by the hotel. I had plenty of time to get into the right spot to capture the image because the show was long enough for me to move around to find the best angle. I used a very high ISO (6400) due to the low light.

1/160 second; F/2.8; ISO 6400

Figure 5.15 On a dive boat off the coast of Mexico with the groom-to-be.

1/100 second; F/10; ISO 400

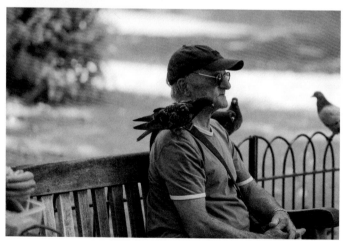

Figure 5.16 I came across this gentleman feeding the pigeons. My camera was ready and I got the shot.

1/200 second; F/4; ISO 200

- **Don't forget family and friends:** I always take lots of photos of the people I am traveling with. Sometimes as photographers, we forget about taking snapshots, always looking to make a great image. Remember to take photos of the people you're enjoying your trip with! The guy in **Figure 5.15** is named Shawn. This shot was taken on a vacation to Cozumel for his wedding.

- **Be ready:** If you come across a great shot, you want to be able to capture it (**Figure 5.16**).

Monuments and Buildings

Lens: You can use any lens to take photos of buildings. However, be aware that architectural photographs can suffer from some serious visual distortions. This has to do with the linear construction of the buildings and the way you hold the camera to get the whole building in the shot. When you hold the camera perfectly parallel to the building it will look normal, but as you tilt the camera up to get the whole building in the frame, the building can start to seem as if it is leaning. You can use this distortion to get interesting images, or you can try to avoid it by making sure the camera is held parallel to the building and you use a lens that closely mimics the natural view (50mm on a full frame and 35mm on a cropped frame).

Exposure Settings: This is one of the few times that I use the program auto mode. It's a great place to start, and you can always change to one of the other exposure mode settings if you need more control.

Shooting Positions: The nice thing about photographing buildings is that they don't move. If you don't like the way the building looks in your shot, all you have to do is wait until the sun moves, or start looking at different angles. You can take all the time you want, since the building isn't going anywhere. I often see buildings or scenes that I want to photograph, and then immediately look for other views that might be more interesting.

Tips

- **Wander all around:** Going to famous buildings and landmarks is great, and something I recommend doing, but it is also a great idea to wander around. The scene photographed in **Figure 5.17** was a building I stumbled across while walking around London.

- **Show scale:** There are times when the sheer size of a building is lost without something else in the shot to show scale, like a person or even a tree. In **Figure 5.18**, the man and his dog in front of the door gives the image a much better sense of scale.

- **Look for all the angles:** Since buildings don't move, you can take your time and look at all the angles. I took **Figure 5.19** while walking around the St. Paul's Cathedral in London. I liked the way the lines of the buildings on either side of me led right to the subject.

- **A good sky can help:** If the sky is overcast and gray, it emanates even, diffuse light. The soft light is perfect for pictures of people. You can also find interesting compositions with unique cloud formations against city skylines (**Figure 5.20**).

- **Check the rules:** Many buildings have rules about photographing inside of them. It's best to check before pulling out the camera. Many religious buildings do not allow photography inside at all, and now with a heightened security concerns around the world, many buildings no longer allow photography.

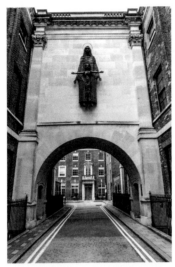

Figure 5.17 Wondering around London, I came across some interesting streets and art pieces. This is the Madonna and Child sculpture by Jacob Epstein at the offices of The King's Fund at Cavendish Square.

1/125 second; F/5.6; ISO 200

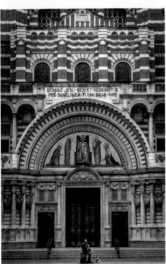

Figure 5.18 The main entrance to the Westminster Cathedral in London, England, was really beautiful and large. The lone person sitting with his dog added some scale to the image. I waited quite a bit for the other people in the frame to wander off before getting this shot.

1/400 second; F/2.8; ISO 100

Figure 5.19 I like the way the buildings draw your eye to St. Paul's Cathedral. I walked around for quite a while looking at all the angles until I found the one I liked the best.

1/800 second; F/5.6; ISO 400

Figure 5.20 Out for a late-afternoon walk in Dallas, Texas, I loved the way the clouds were reflected in the steel and glass of these buildings. It looked to me as if the clouds were floating through the building, which made for an interesting shot. This was shot with -2 exposure compensation to make the scene darker.

1/4000 second; F/4.5; ISO 400

Landscapes

Lens: Landscape photography is usually shot with a wide- to super-wide-angle lens to get the whole scene in the image. The great part about using a lens with a wide range of focal lengths is that you can change the focal length without moving. When shooting landscapes, I usually start at the widest focal length and adjust to get the best composition.

Exposure Settings: Using aperture priority exposure mode will allow you to control the depth of field. For landscapes, you want a deep depth of field where things are in acceptable focus from the foreground all the way to the background. You need a small aperture, like f/16. This will usually result in a slower shutter speed, which means that you need to keep the camera steady during the exposure. If there is enough light, you can handhold the camera, but it is much better to use a tripod. If you don't have a tripod, you can rest the camera on a stable surface and still get a sharp photo.

Focus Settings: For landscapes, I switch to single subject autofocus and make sure the focus point is set on something 2/3 of the way into the frame so that the depth of field covers the whole frame. Remember, the depth of field extends 2/3 in front of the subject and 1/3 behind it.

Tips

- **Go as wide as possible:** Many times I look at landscape photos and they don't seem as impressive as how the scene looked when I photographed it. This is because the focal length I used wasn't wide enough to capture that really impressive vista. Use as wide a lens as possible (or if you want to try something more advanced, you can create a panorama by stitching a set of photos together—more on that later) (**Figure 5.21**).

- **Show some people:** Putting a person (or a few people) in your landscape photo can show a sense of scale, and can also add an interesting graphical element (**Figure 5.22**).

- **Time of day:** The best time to photograph landscapes is early in the morning or early in the evening. The low angle of the sun gives you long shadows and beautiful hues of orange and red in the sky (**Figure 5.23**). Many people pack up right after the sun has set when the sky turns from red to blue, but you should stick around for a little while longer. The cool blue colors can produce some great images.

- **Embrace slow shutter speeds:** Slow shutter speeds blur everything that is moving when you take a photo, so when shooting landscapes, the slow shutter speed will blur moving water or blowing grass in a windy field. This can give the image a painted look (**Figure 5.24**).

- **Consider a filter or two:** If there is too much light to get a slow shutter speed—even shooting at ISO 100 with an aperture of f/16 or smaller—you can use a filter to cut down on the light entering the camera. Neutral density filters block the light so you can use a slower shutter speed. They come in a variety of strengths, measured in stops. I have 1-stop, 2-stop, and 4-stop filters that allow me to shoot with slow shutter speeds even in bright light.

- **Remember basic composition:** A quick reminder that unless you have a really good reason to put it in the middle, you should try to keep the horizon line 1/3 of the way from either the top or the bottom of the frame.

Figure 5.21 The beautiful landscape outside of Sedona, Arizona. This was shot with the widest lens I had and it still doesn't quite show the full vista.

1/200 second; F/11; ISO 100

Figure 5.22 I took this photograph at sunset down by the beach; I made sure to include the people who were out enjoying the view.

1/2500 second; F/5.6; ISO 200

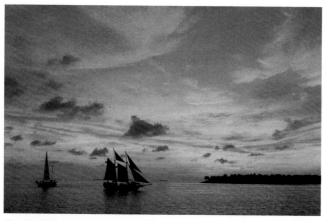

Figure 5.23 I used a slow shutter speed to take this sunset photo in Key West, Florida. If I'd used a shutter speed any slower, the ships would have been blurred.

1/60 second; F/4.5; ISO 200

Figure 5.24 Very slow shutter speeds make water look smooth. You can make shots like these in the evening by using a low ISO and very small aperture. You can make these shots during the day by adding a neutral density filter to your lens to block out some light in order to still use a slow shutter speed.

30 second; F/16; ISO 100

Cities and Towns

Lens: Photographing cities and towns is just another form of landscape photography. Any lens will work, but a wide angle will help you get the whole view in the shot. I like to shoot the city skyline (especially in the evening) from a distance to get it all in the frame, which is possible with the wide-angle lens.

Exposure Settings: During the day, you can use aperture priority or even program auto, but when it comes to shooting at night (and some types of photos look best at night), you need to be more precise. I wrote a whole book on photographing at night and in low light (check out The Enthusiast's Guide to Night and Low-Light Photography from Rocky Nook), if you really want to get into this type of photography, but here are the basics: getting the proper exposure for the cityscapes at night gets tough as the sky gets darker and the evening lights make the city brighter. Here's a way to get a proper exposure:

1. Set the camera on a tripod and compose the image through the viewfinder.

2. Set the exposure mode to aperture priority.

3. Set the metering mode to matrix or scene metering, the ISO to 200, and the aperture to f/16.

4. Press the shutter release button halfway down and see what shutter speed the camera chose.

5. Change the exposure mode to manual and set the shutter speed to the value the camera gave in the previous step, then take the photo.

6. If the resulting image is too light, increase the shutter speed. If the resulting image is too dark, decrease the shutter speed.

7. Keep adjusting and checking as the sky darkens and the lights come on.

Tips

- **Look for high vantage points:** Getting a high vantage point allows you to look down on a city and get great photos. For **Figure 5.25**, I climbed to the top of St Paul's Cathedral in London, where you are not allowed to take photos inside, but are welcome to photograph from the outside. Walking around the outside of the dome gave me a spectacular view of London. While it wasn't the best time to photograph (it was the middle of the day), I was restricted by the times the building was open. Luckily, there was a gritty sky with great texture.

- **Water is great for reflections:** If your travels take you to a city that is next to water, look for a vantage point where you can capture the city's reflection. This can add a depth to the images (**Figure 5.26**).

Figure 5.25 Looking out from the top of St Paul's Cathedral, you can see the Thames and even the London Eye. Luckily, storm clouds rolling in made for a great sky. I used a high ISO so that I could get a deep depth of field and a fast shutter speed because I was handholding the camera in a brisk wind.

1/1250 second; F/16; ISO 1600

Figure 5.26 The San Diego skyline, photographed from Coronado Island. You can see the city reflected in the water.

13 seconds; F/10; ISO 100

Secret Weapons

When I'm walking around taking in the sights, I set my camera in aperture priority mode, and turn on the exposure bracketing. With exposure bracketing set, the camera will take three photos in a row with different exposure settings (one with the settings the camera thinks will yield a proper exposure, one that is underexposed by a stop, and one that is overexposed by a stop). It can be used to create an HDR image, but it can also be used to cover your bases when you're shooting in tricky light. I set the camera to continuous drive so when I press and hold the shutter release button down, the camera takes the three photos in rapid succession. That way I don't miss anything and I don't have to keep adjusting the camera as I find new subjects to photograph. The downside to this is you end up taking a high number of images, but it is a small price to pay to get the shot—especially if you don't know whether you'll ever be back to that spot. In the three images in **Figures 5.27–5.29**, each has a slightly different exposure. Which one is the best? I like the one that is slightly overexposed.

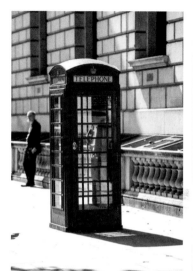

Figure 5.27 The iconic red London phone booth is slightly overexposed (+1 exposure compensation), but it looks better to me than the properly exposed version.

1/1250 second; F/4.0; ISO 200

Figure 5.28 This is the "proper" exposure chosen by the camera.

1/2500 second; F/4.0; ISO 200

Figure 5.29 This is the underexposed version of the image with a −1 exposure compensation applied.

1/4000 second; F/4; ISO 200

Advanced Tips and Tricks

If you want to take it up a notch, these tips and tricks are more advanced. Make sure you know the basics first!

Panorama: A panorama is a single image that is much wider than it is tall (or much taller than it is wide). If you don't have a super-wide angle, you can create a panorama by combining multiple images using image-editing software (I suggest trying this at home before going on your trip to make sure you can make it work well). The basic idea is to take a series of overlapping images that can be automatically combined into a single image. The key is to make sure there is enough information in the overlapping parts of the images that the software can combine them into a single, seamless image. You can see in **Figures 5.30–5.32** the three individual images, and the final panorama in **Figure 5.33**.

Figure 5.30 Downtown San Diego photographed from Point Loma. This is the first of three images used to make the panorama in Figure 5.33.
1/2000 second; F/8; ISO 400

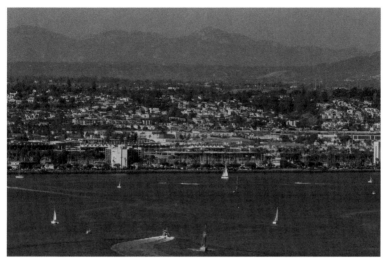

Figure 5.31 The second image used in the creation of the panorama. You can see that there is overlap between this image and the image in Figure 5.30.

1/2000 second; F/8; ISO 400

Figure 5.32 The third image used in the panorama creation. I took all three images in very quick succession so the boats would not move much between the shots.

1/2000 second; F/8; ISO 400

Figure 5.33 The final panorama of downtown San Diego shot from Point Loma. To make the exposures the same on all three images, I set the camera to aperture priority and saw what it chose as a shutter speed. I then changed to manual mode and entered the aperture and suggested shutter speed to keep the exposure consistent.

Platypod: The Platypod (**Figure 5.34**) is a great alternative to a tripod. It's a small, flat support system for your camera that holds everything steady (and doesn't take up a lot of space in your bag). I use one all the time when traveling. It's small, weighs very little, and can hold my camera steady for longer exposures. You can find out more at https://platypod.com.

Figure 5.34 The Platypod with a ball head and camera attached. This is a great tripod alternative that takes up very little space.

PRACTICE

Give This a Try

When we think of travel photography, we usually think of exotic locations. What about where you live right now? Can you find travel photos at home? Think about places or events visitors to your town would want to photograph, and go take some local "travel" shots.

Give This a Try

Get up early and shoot a sunrise. The idea here is to look for a new scene within your familiar location. This will take some planning—you might need to scout a location for your shot the day before so you're not stumbling around in the dark trying to set up your camera.

Take It a Step Further

Go out and shoot a panorama, and to really take it up a notch, shoot one early in the morning or late in the evening. Practice both the long exposure and the panorama techniques. This can be a challenge right as the sun is rising or setting because the exposure can change second by second, making it important to get the individual shots quickly so they blend seamlessly. If you want to try using different exposures, shoot using aperture priority so the depth of field will be the same for each photo.

Notes

CHAPTER
6

SPORTS AND ACTION PHOTOGRAPHY

I love taking action photos. Most of the photos I take could be considered action shots because there is something happening that I did not pose or set up. To get better sports and action shots, first we need to look at what makes a great action photo.

What Makes a Great Action or Sports Shot

A great action shot makes you feel the excitement of the moment. It should make you hold your breath for a second, gasp out loud, and have you looking for more. It might be the thrill of the basket going into the hoop during a basketball game, or your favorite four-legged friend tearing along the beach. These are the photos that grace the covers of sports magazines that get a reader to pick them off the shelf. Here are the things to look for and keep in mind when taking and editing your action shots.

- **Faces:** A shot of a player running down the field away from the camera where all you see is their back doesn't have the same impact as a shot of a player running toward the camera so you can see their face (**Figure 6.1**). Having a face clear in the photo does two things: it allows you to recognize the subject; and it allows you to see the emotion on their face.

- **The Ball:** Get the ball (or the puck) in the shot. The ball is the most important thing in a game and keeping it in the frame helps tell the story of what is going on. A photo with the ball is a soccer action shot—the same photo without the ball is just kids running around (**Figure 6.2**).

- **Peak of the Action:** Capturing the peak of the action, like the puck crossing the goal line or the surfer catching air, will elicit an emotional response from the viewer (**Figure 6.3**).

- **Emotion:** Look for moments after the big play or when one team or player scores. You can either focus on the thrill of victory or the agony of defeat—both will make compelling images (**Figure 6.4**).

- **Conflict:** Many sports are contests between players or teams. The activities have built-in conflict, which makes for interesting photos when captured (**Figure 6.5**).

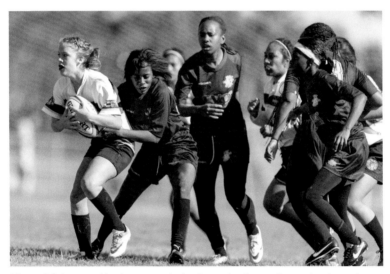

Figure 6.1 I set up this shot to catch the determination on the rugby players' faces as they moved the ball.

1/4000 second; F/2.8; ISO 400

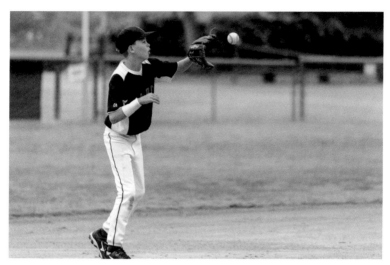

Figure 6.2 Catching the ball in the air on the way to the player's glove isn't tough, it just takes timing and patience. This makes a much more compelling photo than a player standing alone on the field.

1/2500 second; F/4.0; ISO 800

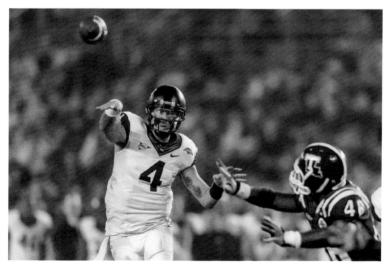

Figure 6.3 Waiting until the quarterback threw the ball allowed me to capture the peak action, leaving the viewer wanting to know what happens next.

1/1600 second; F/2.8; ISO 3200

Figure 6.4 Being set up on one end of the basketball court allowed me to capture the kids driving down the court and the emotion on their young faces as they fought for the ball.

1/250 second; F/2.8; ISO 3200

Figure 6.5 The conflict is clear in this MMA fight image. The two fighters are trying to gain superior position as they grapple on the mat. The photo really works because you can see the expression on the face of the fighter on the bottom.

1/800 second; F/2.8; ISO 3200

What Does It Take to Make a Great Action Shot

There are a few things that every action photographer needs to be able to capture that great action shot. First, you need to know and understand the action or sport you are trying to capture. You need to know what is happening, what is going to happen, where it will happen, and (most importantly) when it's going to happen. This knowledge is the basis of all the decisions you make when photographing. The more you understand what you are photographing, the more likely you are to capture it. Knowing the sport will also help you make decisions on which lens to use, where to stand, and what your initial camera settings should be.

The great thing about the internet is that even if you know nothing about the subject you want to photograph, you can research the activity and find videos, photos, and detailed descriptions on what to expect. When I'm going to photograph an activity that's new to me, I spend some time doing research so I know what gear to use and what settings to start with. For example, before photographing a dog agility competition, I discovered that the course was laid out the same way for each competitor, and that the distance from the viewing area to the finish line would be quite close, but I would still need a longer lens. I also watched the first practice run to pick the best spot to capture the dogs in competition (**Figures 6.6** and **6.7**).

The Starting Point

Having your camera set up properly before you start shooting increases the chances of getting better photos. Here are the settings for photographing action:

- **Exposure Mode:** Shutter Speed Priority. Using this setting allows you to set the shutter speed, making sure you freeze the action. Depending on the action you are trying to capture, the shutter speed needs to be 1/250 second or higher.

- **Drive Mode:** Continuous Drive Mode. This mode lets you keep taking photos as long as you hold the shutter release button down, until the buffer in the camera fills up. At that point, the camera slows down but keeps taking photos.

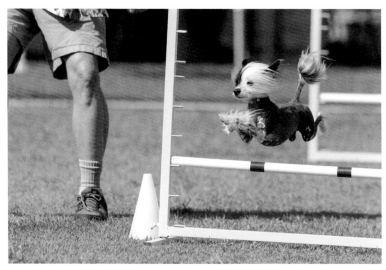

Figure 6.6 Knowing that all the dogs would be running through the same obstacle course made it easy to set up in the best spot to capture them during their run.

1/5000 second; F/4; ISO 500

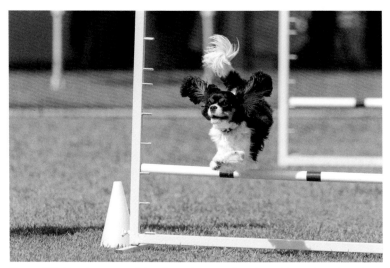

Figure 6.7 Here is a second shot from the same location with another dog going through their run.

1/5000 second; F/4; ISO 500

- **Focus Mode:** Continuous Autofocus. In this mode, the camera keeps trying to focus as long as the shutter release button is pressed halfway down. This mode is designed for action and sports and is by far the best mode to use.

- **Focus Points:** Single Point, Center. I routinely use the single autofocus point in the center of the frame. When starting out, use the focus point(s) in the middle of the frame and move the camera to keep the subject in the middle of the frame. As you become more familiar with capturing these types of images, you can start using different focus points to improve the composition.

The Critical Choices

Lens Choice: The biggest difference between professional sports photos and most people's sports photos is the lens used. Professionals use lenses that allow them to get up close and personal from far away. These lenses are really big, quite heavy, and very expensive, but they make a world of difference. Lenses are described using focal length (as covered in chapter 4), and for most sports you want to use focal lengths of 200mm or longer (**Figure 6.8**). Many pro sports photographers use a 400mm f/2.8 or longer lens (**Figure 6.9**). You see these lenses on the sidelines of most professional sports. There are some less-expensive lenses available that have the same reach, but they do not have wide apertures, and therefore are best suited for outdoor events where there is plenty of available light.

Shutter Speeds Needed to Freeze Action: I have mentioned that the shutter speed needs to be high enough to freeze the action, but what exactly does that mean and how high is high enough? There are four factors that come into play when determining the slowest shutter speed needed to freeze action: the speed of the subject (**Figure 6.10**), the direction the subject is moving (**Figure 6.11**), the distance between you and the subject, and the focal length of the lens you are using. If the subject is moving across the frame, you will need a higher shutter speed compared to if that subject is moving toward or away from you. Think of it this way: if a dog runs toward you, in 5 seconds they will get bigger in the frame; if they are running across the frame, in 5 seconds

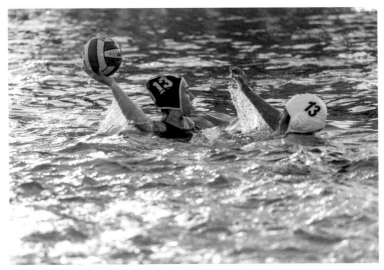

Figure 6.8 The high school water polo game wasn't very far away, but I still needed a 200mm focal length to fill the frame.

1/2000 second; F/2.8; ISO 6400

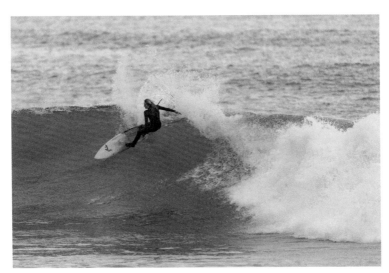

Figure 6.9 This surfer was captured using the Nikkor 200-500mm lens at 500mm since the surfing took place far away from the shore.

1/1000 second; F/5.6; ISO 800

they could cover a huge distance. The closer you are to the subject, the higher the shutter speed needed to freeze the action. The closer you are to the subject, the more they fill the frame and the faster the shutter speed needs to be to freeze them in place. Finally, the longer the lens (the larger the focal length), the less of the scene in front of the camera is captured, so any motion needs to be frozen with a high shutter speed.

Here are recommendations for the minimum shutter speeds needed to freeze different types of action:

- Running person—1/250 seconds
- Basketball—1/500 seconds
- Hockey—1/500 seconds
- Football—1/500 seconds
- Running horse—1/1000 seconds
- Moving car —1/2000 seconds

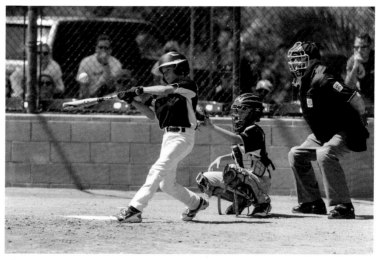

Figure 6.10 I needed a really fast shutter speed to freeze the ball in the air. For this shot, I used a shutter speed of 1/4000 seconds, which is the fastest available shutter speed on many cameras.

1/4000 second; F/2.8; ISO 500

Figure 6.11 Marathon runners can cover more than 25 miles in just over 2 hours. I used a 1/500 second shutter speed to make sure I froze the runner as he was about to cross the finish line in first place.

1/500 second; F/4; ISO 400

Shoot Through the Action: One of the biggest advantages of digital cameras is that you are no longer limited to a roll of film with 12, 24, or 36 exposures. Today's memory cards can hold thousands of images, allowing you to take more photos without worrying about using up all the film. This allows for you to shoot multiple images of the action, so shoot through the moment. Instead of having to get the timing just right, you can start taking photos right before the peak of the action and continue until the moment is over (**Figures 6.12** and **6.13**).

Blur the Background: Some of the best action photos look as if the action is really leaping out of the photo, because the background is blurred so the in-focus action stands out. This is because a shallow depth of field is created by using a wide aperture. The advantage to the wide aperture is that more light is allowed into the lens, which means you can use a faster shutter speed to get that shallow depth of field where the action pops. The downside to using a wide aperture is that your focus needs to be more accurate, because the shallow the depth of field means less of the frame will be in focus (**Figures 6.14** and **6.15**). For sports, a shallow depth of field is best. However, this means using the lenses with the widest apertures, which are the biggest, heaviest, and most expensive.

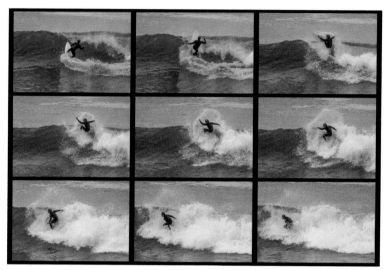

Figure 6.12 These nine frames were taken in quick succession as the surfer rode the wave.

1/4000 second; F/5.6; ISO 800

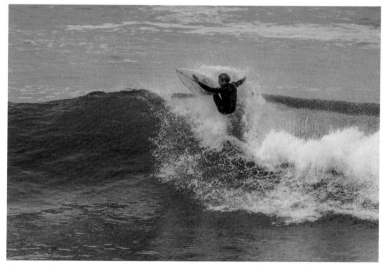

Figure 6.13 Here is the peak of the action from the previous sequence. It was much easier to get this frame (frame 3) by shooting through the ride.

1/4000 second; F/5.6; ISO 800

Figure 6.14 Using a shallow depth of field (f/2.8) kept the players in sharp focus, while the crowd in the stands became a pleasing blur in the background.

1/1600 second; F/4; ISO 3200

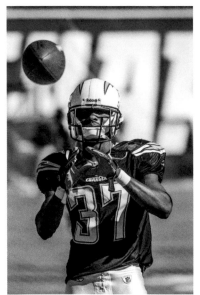

Figure 6.15 Using a wide aperture, even in bright sunlight, creates a shallow depth of field, and the background is blurred.

1/2000 second; F/4; ISO 200

Dealing with Shutter Lag: Shutter lag is the delay between when you press the shutter all the way down and when the shutter is actually moved out of the way and the photo is taken. This happens as the camera is trying to lock focus and move the mirror up and out of the way. This tiny fraction of a second can make a huge difference in your photo, especially if it is a really fast-moving subject. This happens a lot more with compact cameras and point-and-shoot cameras, but the solution is something that everyone can use. To reduce shutter lag, you can prefocus on the point where the action is going to happen by pushing the shutter halfway down. Then when you actually push the shutter release button all the way down, the camera is already focused (**Figures 6.16** and **6.17**).

Figure 6.16 I kept the focus point right on the net, ready to shoot.

1/250 second; F/2.8; ISO 1600

Figure 6.17 Action at the net during a high school volleyball match.

1250 second; F/2.8; ISO 1600

Panning for Motion: This is a technique that uses a slower shutter speed to show motion in the images. It is the opposite of using shutter speeds to freeze the action. With panning, use a slower shutter speed and move the camera with the subject to blur the background while the subject stays in focus. This can give your images a real sense of motion. This works if the subject is moving through the frame from one side to the other; it doesn't work at all for subjects running to or away from the camera. The key to getting good panning photos is moving the camera at the same speed as the subject, so that the subject stays in the same place in the frame and stays in acceptable focus. You can see in **Figures 6.18** and **6.19** that the shutter speed needs to be slow enough that the subject moves enough to get the blur of movement to show. The other side to showing motion is to make sure the background stays in sharp focus while the subjects are blurred.

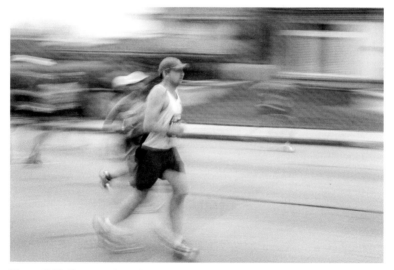

Figure 6.18 Photographing the passing marathon runner, I used a very slow shutter speed of 1/6 second and very small aperture (f/22) to get a blurred background, creating a sense of motion in the image. I moved the camera from left to right at the same pace as the runner to keep him in acceptable focus.
1/6 second; F/22; ISO 100

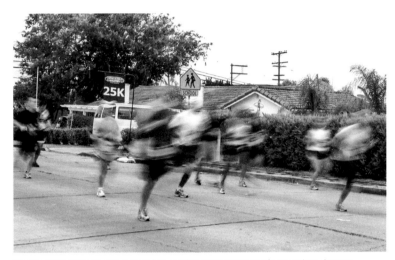

Figure 6.19 This image was taken at the same spot as the previous image, but this time I kept the camera locked into place. With the same settings, the background is sharp and the runners are blurred.

1/6 second; F/22; ISO 100

CASE STUDIES

Soccer

Lens: A regulation soccer field (pitch) is between 110–120 yards long and between 70–80 yards wide. This makes it difficult to get close to the action without a pretty long lens. The ideal focal length is between 200mm and 400mm, which allows you to fill the frame from the sidelines.

Exposure Settings: Most soccer is played outside during the day, which is great because most likely there will be a lot of light, allowing you to use fast shutter speeds. Use shutter speed priority with the shutter speed set to 1/500 seconds or faster.

Shooting Positions: The sideline at center field allows for covering the whole pitch, but it takes a longer lens to cover the action close to the goals. This spot will give you great shots

of the players as they run up (and down) the field. The corner positions allow you to cover the close half of the field and gives you a great angle on the goal, allowing you to get both the player kicking the ball and the goal keeper in the same frame.

TIPS:

- Don't try and chase the ball up and down the sidelines. You will most likely spend a lot more time running than photographing. Wait until the action comes to you (**Figures 6.20** and **6.21**; **Figure 6.23**).
- Look for celebrations after a goal is scored or at the end of the game.
- Keep the ball in the frame.
- Look at the fans for reactions to good and bad moments.
- Ask the coach if you can photograph at a practice. You can practice photographing while they practice soccer (**Figure 6.22**).

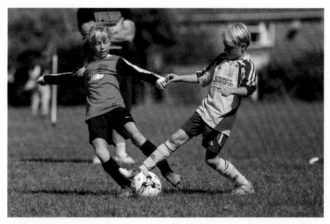

Figure 6.20 Using a 70-200mm f/2.8 at 200mm, I was able to fill the frame with the soccer action when the players were close to me. I was positioned at the sideline close to the center of the field, sitting down to get the low angle. Shooting at f/3.5 made the background blurry, which made the players pop off the background

1/1600 second; F/3.5; ISO 100

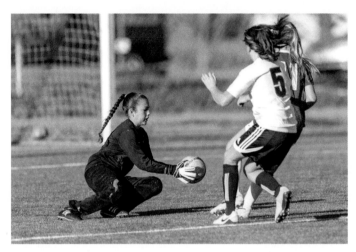

Figure 6.21 Using a longer lens, in this case a 400mm f/2.8 Nikkor, I was able to focus on the goalie from the sideline and still fill the frame with the action.

1/8000 second; F/2.8; ISO 400

Figure 6.22 This was shot during a soccer practice, which allowed me to get out on the field and take photos of the goalie. This shot was also taken during the early evening under a pretty dark sky, which meant I had to increase the ISO to 3200.

1/1250 second; F/2.8; ISO 3200

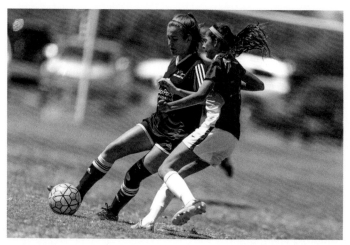

Figure 6.23 Two players fight over the ball, photographed from the sidelines. I used the 400mm f/2.8 lens at f/2.8 to get that blurred background. The focus point is right on the player in the red uniform.
1/8000 second; F/2.8; ISO 200

Little League / Baseball

Lens: A long lens works best for filling the frame, and if you have a lens with maximum aperture of f/2.8 or f/4, it will help in throwing the background out of focus and keeping the attention on the player. This is especially true when photographing the batter in a little league game, since the spectators are right behind them. It's easy to know where to aim the camera because the pitcher is going to pitch the ball to the batter and you can either focus on the pitcher, the batter, or players already on base, depending on your storytelling focus.

The other reason to use a lens with a wide aperture is that it helps remove any of the fence when shooting from the behind the batter. When photographing at f/2.8, get as close to the fence as possible, and the shallow depth of field makes the fence

disappear as the camera focuses on the pitcher. You can see this in **Figure 6.24**.

Exposure Settings: Baseball is not known for being a particularly fast-moving sport, but that is a myth when it comes to capturing a fast pitch and the swing of the bat. The good news is that you know where the action is going to happen; the bad news is that it's really fast, and getting that moment when the bat hits the ball is difficult. Your timing has to be perfect and your shutter speed needs to be fast enough to freeze the ball and bat. I use shutter speed priority to make sure the camera is using the shutter speed I want and not changing it depending on the light from frame to frame. Use a shutter speed that will freeze the action and the widest aperture available.

Shooting Positions: There are numerous great spots to capture baseball. With little league and kids just having a good time, look for the spots past the dugouts, which allow you to capture the batter, catcher, and even the official behind the plate (**Figure 6.25**). You can also photograph directly behind the batter for a great shot of the pitcher. One thing that you might want to try is photographing a practice (**Figure 6.26** was taken right next to the pitcher behind a safety screen). You will not be able to get this type of shot during a game.

TIPS:

- **Get as close as you can:** For kids' games, you can get right on the sidelines or at least in the first row of seats. Check to make sure that you are not in a position that is going to be in the way. The best bet is to check with the coach or the official before the game. For college, semipro, and spring training, you can still get pretty close, but access is more tightly controlled, so ask the league before showing up. It works best if you have an outlet that you are photographing for.

- **Show the ball:** A baseball photo is more compelling if the ball is in the shot.

- **Increase the ISO:** You need to use a fast shutter speed. If the day is cloudy or the team is playing at night, increase the ISO to get that faster shutter speed.

- **Show the faces:** There are some great baseball moments that happen even without the ball, like a player sliding into the base, or the reaction to a play by the players in the dugout. Focus on the faces so that the viewer can see the emotion (**Figure 6.27**).

- **Anticipate the action:** It really helps to understand the game so you can know what is going to happen. For example, if there is a runner on third, and the batter makes contact, watch to see if the runner makes it over home plate and scores a run. If your attention is on the wrong thing, you will miss those important shots.

- **Have a plan:** Are you shooting the game for one team or both teams? Do you have a player you need to follow both when batting and fielding? What is the story you are trying to tell? The answer to these questions will dictate if you stay in one spot all game and just photograph all the batters or if you will move to cover a team or player exclusively.

Figure 6.24 Photographing from the spectator area behind the chain link fence doesn't mean the fence has to be in your image. Get as close as possible and focus on the pitcher using a shallow depth of field and the fence will magically vanish.

1/4000 second; F/2.8; ISO 500

Figure 6.25 Photographing from just past the dugout on the third-base side allows me to capture the batter, catcher, and umpire in a single shot. Here, you can see the ball has been hit and is nearly out of the frame. The batter took off running right after this was taken.

1/4000 second; F/2.8; ISO 500

Figure 6.26 Photographing during a practice can get you great images and the pressure is off since it isn't a real game. You can get images that are not possible during a real game, like this one of batting practice where I stood next to the coach behind a protective screen, to get the ball on the bat from the front angle.

1/4000 second; F/4; ISO 400

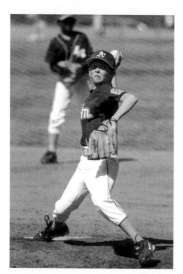

Figure 6.27 The determination on the face of the young pitcher makes the photo. Keep the focus on the eyes of the players and pay attention to the expressions.

1/2000 second; F/4; ISO 200

Surfing

Lens: You need a really long lens to photograph most surfing. Many of my surf photos were taken at 600mm or even more (**Figure 6.28**). There are times that a shorter lens will work, and I will cover those in the shooting positions section, but to really capture surfing you need a long lens.

Exposure Settings: There is plenty of light when photographing surfing. Most surfing takes place during the daylight hours, making it easy to get action-stopping shutter speeds with middle-of-the-road apertures like f/5.6 and f/8. The bigger issue is that the scene can be read differently by the built-in light meter depending on the wave and the weather. Here is a method to get a good exposure for shooting surfing:

1. Set the camera to aperture priority mode, the aperture to f/5.6, and the ISO to 400.

2. Focus on the surfers and take a photo.

3. Look at that photo and decide if the image is too bright or too dark.

4. If it is too dark, increase the ISO and try again until it is bright enough. Then check the shutter speed. You need to make sure that the shutter speed is at least 1/640 second to freeze the action. Then switch to manual exposure mode and enter the settings.

5. If the image is too bright (this is the case 99% of the time), switch to manual mode and enter the settings from the test shot, then start to increase the shutter speed. You need a minimum of 1/640 second, but faster is better.

6. Now you have the proper settings to photograph surfing, at least until the light changes and you have to increase the shutter speed (due to the scene becoming brighter) or you need to increase the ISO (due to the scene becoming darker). Just check the photos after each sequence and adjust accordingly.

Shooting Positions: There are three places to photograph surfing: the beach or shore, in the water, or over the water. I am not covering surf photography from in the water in this book—it takes specialized equipment, a really good knowledge of the sport, and being a really good swimmer. Photographing from over the water happens if you are in a boat watching the surfing (which is rare), or on a pier overlooking the surfers. If you are in an area where you can shoot the surfers from the pier, you can photograph the action from a pretty cool angle, and you don't need a really long lens. As you can see in **Figure 6.29**, photographing down at the surfer as they glide past the pier captures an interesting view of a familiar sport.

Photographing from the beach or shore is the most common way to capture surfing. The downside to photographing from the beach is the distance to the action. Before you set up your camera, watch the surfing to figure out your best angle for your shot. Are you in a good position to get the whole ride? Or are most of the surfers riding away from you? You want to be set up to catch the peak of the action.

Tips:

- **Leave Space in Front:** When photographing sport or action events and a participant is moving across the frame, leave them room to move into so they don't seem crammed up against the edge of the frame, as seen in **Figure 6.30**.

- **Watch the Horizon:** Try to keep the horizon straight. It can be distracting to have it crooked—especially when it's just crooked enough to seem unintentional.

- **Monopod / Tripod:** Use a monopod (or a tripod) to help support that long focal length. It's a lot easier than trying to handhold the lens all the time. Settle in for a nice relaxing time at the beach and let the monopod or tripod do the heavy lifting. Pay attention if you are shooting on the sand that the monopod or tripod doesn't sink, causing you to drop your gear in the sand or water.

- **Use a Teleconverter:** Teleconverters are devices that mount on your camera between the camera and the lens. They increase the reach of the lens but decrease the maximum aperture—which a great trade-off when you are shooting in lots of light. Some people don't like to use these because they can diminish the image quality, but when you are shooting from so far away, they really are a great tool.

- **Shoot a Sequence:** Shoot using continuous autofocus and continuous drive. Instead of trying to get the best action with a single shot, shoot in bursts of 2-3 each time. Follow the surfer along the whole ride, capturing images as you go.

- **Before and After:** Look for surfers leaving the water or watching the waves before they go out for a session. These make great storytelling photos, especially when viewed in series with the rest of your action shots (**Figure 6.31**).

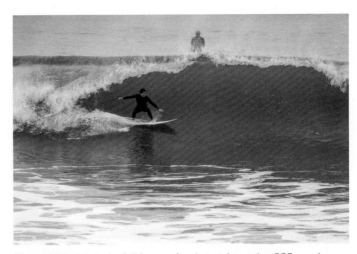

Figure 6.28 This is the full frame of a photo taken using 800mm. As you can see, there is plenty of empty, boring space around the surfer, distracting the viewer.

1/4000 second; F/5.6; ISO 800

Figure 6.29 Photographing down from the Ocean Beach pier, I was able to capture some unique angles.

1/5000 second; F/4; ISO 500

Figure 6.30 I left space in front of the surfer so that he didn't look crowded up against the edge of the frame. You have to continuously adjust your composition as they ride the waves.

1/3200 second; F/4; ISO 500

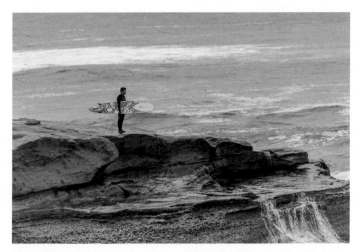

Figure 6.31 The bright colors of the surfboard stand out against the background. I photographed this while the surfer waited for the next set of waves to break so he could head out into the surf.

1/5000 second; F/4; ISO 500

Hockey and Basketball

Lens: Photographing indoor sports means you can sometimes get close to the action. Depending on where you are photographing from, you might be able to use a shorter focal length. When I shoot basketball and have a static position on one end of the court, the action at the other end can be captured with a 200mm lens, while the action up close needs a much wider focal length. When shooting hockey from the ice level, a 200mm lens works for the action on the far side of the ice, but a wide angle is useful for when the action is up close.

Exposure Settings: Ice hockey moves really fast, so you need a fast shutter speed to freeze the action. I use a shutter speed of 1/500 second, and there is still sometimes blur in the hockey stick and the puck, especially with hard shots at the goal.

Basketball moves slightly more slowly that hockey, but you still need a pretty fast shutter speed to freeze the action. The advantage is that because these sports are played inside, the lighting is constant. Once you have the right settings, you don't have to change them. I recommend using shutter speed priority and setting the shutter speed to 1/500 second with an ISO of 1600 and a fast lens with a maximum aperture of f/2.8. Both of these sports can be shot in manual exposure mode, which is explained at the end of the chapter.

Shooting Positions: When professionally photographing professional basketball or ice hockey, there are set places for the photographers to shoot from. With basketball, it's at the ends of the court, and you are not allowed to move during the quarter. With ice hockey, the photographer positions are toward the end of the ice, and you shoot through a hole in the glass that surrounds the rink. These positions limit what you can actually shoot, since half the action happens on the other side of the court or rink. For the shots on the other side of the rink or court, a longer lens is needed; when the action is up close, a shorter lens is needed. Both sports can be quite hazardous to shoot, since you are very close to fast-moving action. Shooting kids' hockey or basketball is easier because you can usually shoot from the stands or the seats.

TIPS:

- Know the game. I cannot stress this enough, especially when it comes to ice hockey. You have to know where the puck is going because the game (and the puck) moves so fast. That small black puck can travel at 100 mph during the game, making it nearly impossible to follow with your camera unless you know where it's headed (**Figure 6.32**). Basketball isn't quite as fast, but the erratic movements and passes designed to fake out the other team can also fake out the photographer. Knowing generally how the action is going to happen makes all the difference between getting the shot and missing it. The same goes for the players. Is the player known for dunking the

ball, or do they prefer the outside jump shot? Knowing who they are will help in anticipating the shot.

- When in doubt, watch the ball or puck (**Figures 6.33** and **6.34**). When you find that the sport is moving too fast, pay attention to the net or the goal (remember, there are many more chances in basketball to get the ball in the net than there are in hockey to get the puck in the goal).

- Be safe. Since both sports have photographers right up close to the action, you need to be aware of your surroundings and be safe at all times.

- Experiment with the shutter speed. Slowing down the shutter speed a little can really help to show the speed of the game. This is particularly evident when shooting ice hockey because you can freeze the player, but the stick and puck might have some blur showing their movement while everything else is still (**Figure 6.35**). Start at 1/500 second, then try 1/250 second.

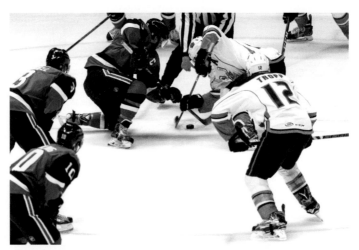

Figure 6.32 Knowing what happens when the puck is dropped allowed me to capture the puck on the ice before the players went into action. 1/500 second; F/2.8; ISO 1600

Figure 6.33 It's pretty easy to keep the focus on the ball when it's kids who are playing the sport. Here, I kept tracking the ball as the two teams fought for possession.

1/500 second; F/2.8; ISO 800

Figure 6.34 The low angle of this shot really allows you to feel like you are right in the middle of the action.

1/500 second; F/2.8; ISO 1600

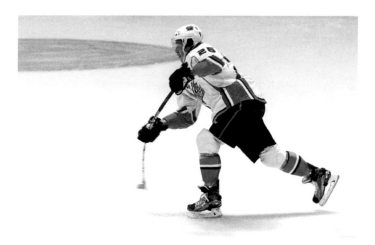

Figure 6.35 The puck moves really fast when a player shoots for the goal. Even at 1/500 second, the speed of the stick and the puck can become a blur while the rest of the scene is sharp. For younger players, try a slower shutter speed.

1/500 second; F/2.8; ISO 1600

Secret Weapons: Lens Rental and Cropping Later in Software

One of the biggest issues with shooting sports and action is the distance the photographer is from the subject. This means using a long lens to get close to the action, but those lenses can be expensive. You can rent those long lenses for a weekend or a week from either your local camera store or an online rental company.

Using a lens with a focal length of 200mm or longer poses its own challenges, and I strongly suggest that you practice using one before that important shoot. I often use a 400mm lens for the bigger sporting events. These lenses are great for allowing you to get in close to the action, but they are heavy, difficult to handhold, and expensive. When I use a longer lens I support it with a monopod, which allows me to keep it stable while moving it quickly to follow the action.

If you still don't have exactly the framing you want, you can get closer to the action by cropping the image in post-production.

Advanced Tips and Tricks

If you want to take it up a notch, here are some tips and tricks for advanced photographers.

- **Aperture priority:** Many photographers use the aperture priority exposure mode to take sports photos instead of using shutter priority because you can control the depth of field and the shutter speed for more consistent results by choosing the aperture (**Figure 6.36**). When you pick aperture priority mode, the camera uses the built-in light meter to determine the shutter speed, so the camera will use the fastest shutter speed available.

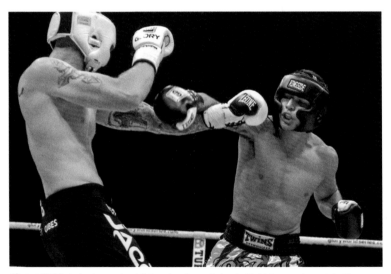

Figure 6.36 I photographed this mixed martial arts fight in aperture priority mode and a high ISO, which gave me a shutter speed fast enough to freeze the action.

1/800 second; F/2.8; ISO 3200

- **Back-button focus:** I covered back-button focus back in chapter 3. This focusing technique works great for sports.

- **Manual mode for consistent lighting:** There are some locations where the action takes place under consistent lighting. For example, the venue where I photograph hockey has even lighting, making the exposure settings really easy to choose. In these situations, you can (and should) use the manual exposure mode to get consistent results, and you can spend more time concentrating on the composition knowing the exposure is set properly. Here is how to get the best results:

 1. Set the camera to aperture priority.
 2. Set the aperture to the desired size.
 3. Aim at the subject you want to capture and press the shutter button halfway down.
 4. Check to see what the camera picks for the shutter speed.
 5. If the shutter speed is too low (check the chart in the previous section), raise the ISO and check again. Repeat this until the aperture, shutter speed, and ISO combination can freeze the action you are shooting.
 6. Change the exposure mode to manual.
 7. Set the aperture (same as the previous step).
 8. Set the shutter speed manually (same as the previous step).
 9. Take a photo.
 10. Check the photo on the camera's screen.
 11. If the picture looks too bright, increase the shutter speed or decrease the ISO by a stop, and check again. Repeat this until the exposure looks the way you want it to.
 12. If the picture looks too dark, increase the ISO or use a wider aperture if it's available.
 13. Once the settings are set, you should not have to worry about them again.

This is how I set my camera when photographing hockey, since the light does not change at all during the game. In **Figures 6.37–6.39**, you can see a photo taken in aperture priority mode, then in manual with the same settings, and then, since I like the ice to be a brighter white, overexposing the photo by one stop.

Figure 6.37 Taken in aperture priority mode, the camera tries to get a neutral gray overall, making the ice look too gray and dark for my taste.

1/1000 second; F/2.8; ISO 1600

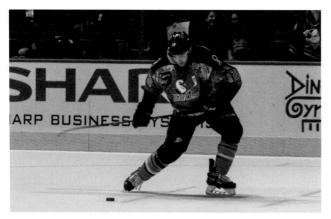

Figure 6.38 I set the camera to manual mode and used the same settings (1/1000 sec shutter speed and f/2.8 aperture), but the scene still looks too dark for me.

1/1000 second; F/2.8; ISO 1600

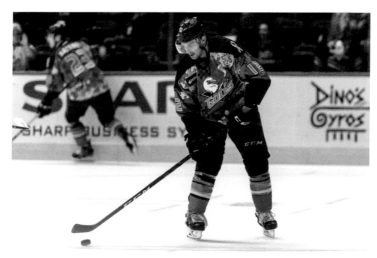

Figure 6.39 I decreased the shutter speed to 1/500 seconds, which made the image brighter, and much more appealing. This is a full-stop decrease in the exposure from 1/1000 seconds to 1/500 seconds. The 1/500 is still fast enough to freeze the players, but there will be some blur on the moving puck and possibly the hockey sticks during a shot.

1/500 second; F/2.8; ISO 1600

PRACTICE

Give This a Try

It's time to play with shutter speeds. How fast does the shutter speed need to be to freeze the action? For this you will need a friend, or to go to a location where people are moving at a fast pace (my favorite fast-moving subjects are my dogs at a sprint). Set the camera to shutter speed priority and start at a slow shutter speed (1/30 second works well). Take a couple of shots of your subject. Increase the shutter speed to 1/60 second and repeat. Keep increasing the shutter speed and, if needed, the ISO until you reach the top shutter speed on your camera (probably 1/4000 second, but it could be 1/8000 second). Take note of how the higher shutter speed freezes the action and what ISO is necessary for these shots.

Give This a Try

Practice shooting at f/2.8. This might seem simple, but when you shoot fast-moving subjects with a very shallow depth of field, it can be difficult to keep the right subject in focus. You will want to use continuous autofocus and aperture priority, and keep the AF point right on the subject.

Take It a Step Further

If you really want to step up your action-photo game, rent a 400mm f/2.8 lens. This is a big, heavy, expensive lens, but it can really get you in close for those "fill-the-frame" action shots. These lenses can cost quite a bit to rent and even more to own, but they are the go-to lenses for professional sports photographers. Check to see if your local camera store has one to save yourself the money for the shipping costs associated with renting a lens online. You will need a monopod to use this lens because it is too heavy to handhold for more than a few minutes.

Notes

CHAPTER
7

EVENT PHOTOGRAPHY

Photographing events is what I do most. While it can be quite challenging, especially when shooting in low light, the rewards are worth it. I love being able to capture that special moment at a concert or play that transports people back to that event when they see the photo. Event photography covers a wide range of subjects, from plays to concerts to weddings, and just about everything in between.

What Does It Take to Make a Great Event Photo

A great event photo should be able to transport the viewer back to the event or make them want to go to the next event. Here are a few things to keep in mind for successful event photos.

- **Show the emotion:** Capturing emotion is tough. You have to really pay attention to the faces of the people and the mood of the event (**Figure 7.1**).

- **Focus is critical:** Due to the wide apertures needed to shoot in low light, you need to make sure that your focus is spot on. For the photo in **Figure 7.2**, I used a single autofocus point to get the focus on the face of the drummer and not the surrounding kit.

- **Tell a story:** Look to capture all the parts of the event, from before the doors open to when the event is winding down.

- **Timing:** Look for the peak action shots and be ready to capture them. This is especially important when it comes to performing arts such as dance, where a fraction of a second can make the difference between a great shot and a mediocre shot. When I shoot any of the performing arts, I run the photos by the dancers or performers before making any of them public. That way I can be sure that the poses that I captured are flattering (**Figure 7.3**).

- **Obey the rules:** Many times there are rules and restrictions when it comes to shooting events (e.g., no photography allowed in a synagogue during the Sabbath; concert photographers can only shoot during the first three songs; you can shoot during a play rehearsal but not during a performance). Know the rules up front and if you are not sure, ask before the event (**Figure 7.4**).

Figure 7.1 It's pretty easy to read the emotion coming from the young fan on stage with Cody. Her facial expression and body language give it all away.

1/4000 second; F/2.8; ISO 400

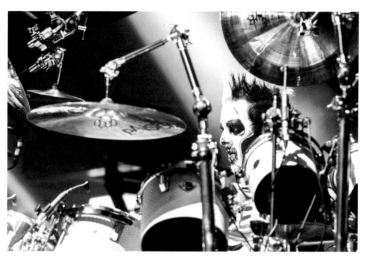

Figure 7.2 You really have to know your camera gear and what focus point to use when trying to capture a drummer behind the drum kit, surrounded by all kinds of stuff that could easily pull focus. I used a single focus point right on the face of the drummer. The stark contrast between the white and black face paint gave the focus system a lot to work with.

1/320 second; F/2.8; ISO 800

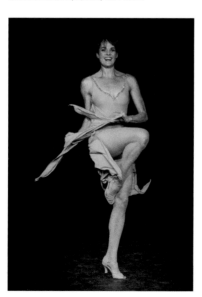

Figure 7.3 Photographing dance is not easy. You have to wait until the perfect moment to take the photo. Many times there are little things that the photographer might not know about a pose or movement, so it is best to ask the performer, director, or choreographer for help in determining the best shot.

1/500 second; F/2.8; ISO 1600

Figure 7.4 This photo of the bar-mitzvah boy reading from the Torah was set up before the bar mitzvah started because photography is not allowed in the synagogue on the Sabbath.

1/80 second; F/8.0; ISO 400

A great deal of work goes into photographing an event successfully, and most of it happens before the event even starts. Here are some things to consider when preparing to photograph an event.

- **Preparation:** A lot of prep work goes into shooting an event. The more you know about what is going to happen, where it is going to happen, and when it is going to happen, the more you can plan ahead. This information can help with deciding on camera gear and what settings you will need depending on the event's time and location. For example, before I photograph a conference, I try to find out if it will be inside or outside, and if I will be close to the subjects or far away. This helps me determine what lens I will use.

- **Go early:** I am always early for every event I ever shoot. This extra time gives me an opportunity to look around and start planning out places to take photos or have people pose (if that's my job) (**Figure 7.5**).

Figure 7.5 The creator, cast, and producers of the television show The Simpsons at the 2017 San Diego Comic-Con. To get this shot, I had to be ready when they showed up to do the signing and I had to direct them where to stand and look. All during this time I had to adjust my camera and flash to get the best exposure. Since I new exactly when they would be at the booth, I was already set to go and the shot took less than a minute to set up and take.

1/80 second; F/5.6; ISO 1600

- **Know when to use the flash:** Being an event photographer means that at some point you are going to have to learn how to use the flash on your camera (or more likely an external flash mounted on your camera). There is more on this in chapter 8.

- **Shoot using RAW:** Your camera can save the images as either JPEG images or as RAW files (NEF for Nikon, CR2 for Canon) (**Figure 7.6**). Shooting in RAW gives you an image file that allows for more editing potential because it has more of the actual image data than the processed JPEG files. However, the RAW files need to be processed before being easily shared and printed, which means you need an image-editing program that can process RAW

files. The good news is that most cameras allow you to save a RAW and a JPEG each time you take a photo. This means you can learn how to process RAW images at your convenience and you will still have the JPEG in the meantime (**Figure 7.7**).

Figure 7.6 Screen capture of the file formats on my camera. The Nikon D750 allows me to shoot RAW and JPEG at the same time so I end up with two versions of the photo.

- **Know your gear:** Shooting parties and conferences, you often find yourself walking to various locations to take photos. These different locations are all probably lit differently, which means you have to be able to change the settings on your camera and flash really fast. Study and use your gear at home so that when you are out taking photos you don't have to worry about fumbling with settings.

- **Work fast:** Event photography is really fast paced, mainly because there isn't very much time for the photographers. It doesn't matter if you are covering a speaker at the podium or taking candids at a cocktail reception—no one is there to just get their photo taken (**Figure 7.8**).

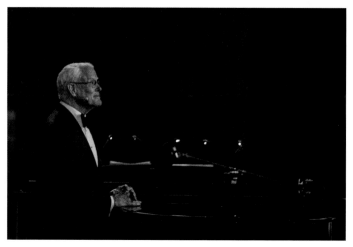

Figure 7.7 During a presentation at an anniversary gala, there was a tribute video playing and the man being honored turned to watch the video. I was ready to take the shot, but the exposures were tough. Since I was shooting in RAW, I managed to get back some of the details that were lost in the original file.

1/50 second; F/2.8; ISO 1600

Figure 7.8 I only had a few seconds with the cast of *How I Met Your Mother* before they were whisked away. Being able to work fast is a must when it comes to event photography.

1/60 second; F/5.6; ISO 500

Getting Started

Having your camera set up properly before you start shooting increases the chances of getting better photos. Here are the settings for photographing action:

- **Exposure Mode:** Manual / Aperture Priority. I switch between manual and aperture priority modes depending on the type of event I'm shooting. For concerts and other indoor or low-light action-type shots, I use manual mode. For conferences and other events when I am using a flash or there is plenty of available light, I usually use the aperture priority mode.

- **Drive Mode:** Continuous Drive Mode. This mode lets you keep taking photos as long as you hold the shutter release button down. When the buffer in the camera fills up, it slows down, but keeps taking photos. I usually shoot a three-to-five shot sequence during many concerts and I usually shoot two to three shots in a row when shooting other events—especially when using a flash to try and avoid people blinking.

- **Focus Mode:** Continuous Autofocus. In this mode, the camera keeps trying to focus as long as the shutter release button is pressed halfway down. This mode is designed for moving subjects, and most of the time the people at parties and events are moving, making this the best mode to use for successful shots.

- **Focus Points:** Single Point. I routinely use the single autofocus point and move it around to keep it on the main subject. This allows me to frame the shot with the main subject off-center (remember the rule of thirds).

The Critical Choices

- **Lens choice:** Event photography covers a wide range of lighting conditions, from bright outdoor weddings to dark indoor performances. For dark events, you will need a lens with a very wide maximum aperture. For receptions held outside in the midday sun, you can use just about any aperture. The two lenses that I use most in my event work are the 24-70mmf/2/8 and the

70-200mm f/2.8. These two lenses give me a lot of options, and because they both have a constant maximum aperture of f/2.8, I can use them in every light.

- **Push the ISO:** When you need to shoot in low light and you might not have a lens that opens all the way to f/2.8, the next best step is to push the ISO up so that you can still get sharp photos. Make sure that the shutter speed doesn't drop too low, creating blurry images.

- **Learn flash:** Many photographers don't quite understand how to get the best from their small flashes, so they tend not to use them and instead rely on natural light. To become better at covering events, you will need to learn how to use your flash. The next chapter in this book has a lot more information on using a flash to take portraits.

CASE STUDIES

Plays and Dance Performances

Lens: The lens needed here will depend on the distance you are shooting from, and how much of the scene you want to capture. My style is to try and get as close as possible and use a long lens to isolate the subject in the frame. This usually means I am using the 70-200mm lens. Since most of these types of events happen in dark places, I use the lens that opens to a f/2.8. The downside is that this is an expensive lens. There are less expensive options, like the 70-200mm f/4 version. It's not quite as fast, but less expensive. Of course if you are able to get even closer or want to photograph the whole stage, you can use a much less-expensive 50mm f/1.8 lens that works great in low light.

Exposure Settings: The lighting during a play or recital is usually pretty constant, which makes it easier to get properly exposed images. This is what I do:

1. Set the metering to spot metering and make sure the focus point or spot-metering area is over the performer.

2. Set the camera in aperture priority mode and set the aperture to f/2.8 or f/4 (the widest opening available to you).

3. Set the ISO to 1600 and compose the scene through the viewfinder.

4. Press the shutter release button halfway down and notice the shutter speed the camera chooses.

5. Change to manual mode and enter that shutter speed.

6. Take a photo.

7. If the photo is too bright, increase the shutter speed and try again. If the photo is too dark, decrease the shutter speed and try again.

8. If the photo is blurry, increase the ISO and the shutter speed and start the process over.

You should now be able to take photos with the exposure locked down. If the lights change, just adjust the shutter speed up or down as the lights gets brighter or dimmer. It takes practice, but when you have it down, you can adjust the exposure just by adjusting the shutter speed in small increments. I set the exposure using this technique when photographing Armando in **Figure 7.9**. This allowed me to focus on capturing the action as he performed on the aerial silks.

Shooting Positions: The best view to photograph a play or dance recital is right from the audience. The performance takes place for the audience, and that is the view you should try to capture. If you are photographing a friend or family member in any type of production, please remember that there are other people in the audience who are probably trying to capture their friend or loved one, so be courteous. If you are able to photograph a rehearsal, then you don't have to worry as much about disturbing the people around you as you would in a full production.

Tips

- **Know the subject:** It is much easier to capture a great moment during a performance if you know what to look for. For example, I photograph an aerial dance company regularly, and I've learned how to anticipate spectacular moments (**Figure 7.9**). When I started out, I watched them rehearse so I would understand what to look for. I also asked the dancers to look at the photos and tell me which ones were good (and why), and which ones were bad (and why). This taught me what to look for when taking their photo. Simple research is a great way to familiarize yourself with a performance.

- **Shoot the rehearsal:** This is the best thing you can do. It doesn't matter what the production is, if you can get permission to take photos during a rehearsal (or two), you will have less pressure and more access. I always ask if I can photograph the rehearsal (**Figure 7.10**), even if I am going to be shooting one of the actual shows (**Figure 7.11**). It allows me to know the flow of the show and to plan out what to shoot.

- **Use silent mode:** This is a game changer for shooting in quiet places. Many newer cameras have a fully silent shooting mode, which means they can be used without making a sound. This is a great breakthrough for photographers who shoot in very quiet places, such as plays or dance recitals. Check your camera manual on how to do this and use it when shooting from the audience.

- **It's all in the timing:** This is critical when photographing dance because you are trying to capture the peak of the action. I usually shoot in continuous mode and try to take a quick burst of photos during the most exciting moments to make sure I don't miss anything. In **Figures 7.12** and **7.13**, I photographed these performers both during performances and rehearsals, which increased my ability to get the timing just right.

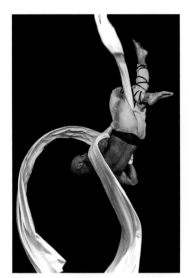

Figure 7.9 I used Manual mode to keep my exposures consistent while photographing Armando. I was not interested in showing the background; I wanted the focus to stay on the actor.

1/400 second; F/2.8; ISO 1600

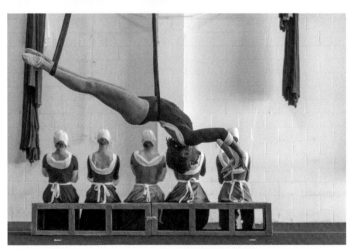

Figure 7.10 Photographing the rehearsal lets me know what to expect during the show. Here, you can see the shot taken during one of the final dress rehearsals. The next photo is the same scene shot during an actual performance.

1/250 second; F/2.8; ISO 1600

Figure 7.11 The talented Astraeus Aerial Dance Theatre during a performance of their award-winning "Echoes of Gallows Hill."

1/400 second; F/2.8; ISO 1600

Figure 7.12 Capturing a dancer at the exact right moment takes practice and a little bit of luck. The more you practice, the less luck you'll need.

1/160 second; F/2.8; ISO 1600

Figure 7.13 Capturing Laura in the middle of her routine took careful timing. It was a good thing that I had seen this routine numerous times, so I knew when she was going to go into this pose.

1/2000 second; F/4.0; ISO 1600

Conferences

Lens: I photograph quite a few conferences a year, from smaller events with a few hundred people to the San Diego Comic-Con with over 130,000 attendees. I use a variety of lenses depending on what I am covering—everything from a 16mm fisheye lens to a 300mm telephoto. The key to deciding which lens to use is knowing what you are gong to be covering. My most common lens when working at Comic-Con is the 24-70mm because it allows me to get a wide and medium shot with the same lens, and most of the time I am working pretty close to my subjects.

Exposure Settings: I use aperture priority and manual exposure modes. When using a flash, I use aperture priority mode with matrix metering, which gives me pretty consistent results, since the camera does a lot of the work for me. I usually set the aperture to f/5.6, which will make sure the person I am

photographing is in focus, but the far background will start to blur. I use manual mode when shooting in spots where the flash is not allowed or the distance is too great for the flash to work. Then I work out the exposure in the same as I do when shooting plays or dance performances.

Shooting Positions: If you are attending a conference and looking to get a few photos, look for the sightlines before the subject is in place. For example, if an author is signing a book, or someone is giving a presentation, can you walk up and get a photo from up close? Or will you have to stand back and shoot from a distance? Knowing where you can shoot before the event starts makes it easier to get the right settings and be ready when the subject is present. If you can get your camera set up before you actually need to take the photo, all the better.

Tips

- **Pose people:** If you are working the conference and need photos of people, just ask them. Most people will be happy to pose for a quick photo as long as you are polite and fast. No one wants to spend all their time posing for photos when they are at an event. Sometimes getting people to pose is pretty easy, especially when they are dressed in costume, as you can see in **Figure 7.14**. Part of my job is trying to get group photos of the casts of television shows who are signing autographs during Comic-Con. I direct the subjects to look at me for the group shot before they sit down and begin signing. Yes, I'm nervous, but it just takes a few seconds, and the worst that can happen is they ignore me. Figure 7.15 shows the cast of the show Cosmos right before they met their fans for a poster signing. Posing people also goes for the fans, many of whom go to the conventions dressed as their favorite characters. Figure 7.14 was taken during WonderCon, where costumed fans willingly posed.

- **Think wide, medium, and close-up:** To show the scope of the conference, it's best to always think in terms of wide, medium, and close-up shots—and you want all three (**Figures 7.16–7.18**). This is why I love the 24-70mm and the 70-200mm lens combination. It offers me a wide view, a middle view, and a close-up view. Don't get stuck shooting a single focal length!

- **Be ready:** As a conference photographer, I am always ready to take a photo. My cameras are with me, the batteries are charged, I have a formatted memory card ready to go, and my cameras are all set for whatever lighting conditions are present. Stuff happens really fast, so be ready to stop and take a photo at all times.

Figure 7.14 Capturing characters dressed in costume is all part of the WonderCon experience. They will pose if asked, and I ask—a lot.

1/2500 second; F/4.0; ISO 800

Figure 7.15 The cast of the TV show *Cosmos* poses for a quick group shot before the poster signing begins.

1/60 second; F/5.6; ISO 1600

Figure 7.16 I captured this whole scene from the back of the room with a wide-angle lens, including the room layout and how crowded is was. This was taken with a 20mm lens to get as much of the scene in the frame as possible.

1/100 second; F/2.8; ISO 1600

Figure 7.17 The middle-range view of the same scene. You can still get a sense of the room and the crowd, but now the focus is on the speaker. This was shot at 70mm.

1/400 second; F/2.8; ISO 1600

Figure 7.18 Finally, a close-up that focuses solely on the speaker and doesn't show any of the room or the crowd. Taken at 200mm.

1/400 second; F/2.8; ISO 1600

Wedding

A wedding is one of the most important days in a couple's life and they are entrusting a photographer to capture their special moments. If you are at a wedding as a guest, please let the photographer that the couple has hired do their job.

Lens: Weddings can be divided into four separate parts, and each part needs different gear. The first part is the photos taken before the wedding of the bride and groom getting ready. These are a combination of posed and candid photos and can usually be taken with a lens that has a normal view, using for example, a 50mm or 35mm lens. The second part is the ceremony. The lens choice here will be determined by the location of the ceremony and where you will be shooting. My favorite for these shots is the 70-200mm focal range, because it allows me to get in close without being in the middle of the wedding. Next, it's time to think of portraits of the couple, the wedding party, and the family. For portraits of the couple, I like the longer focal lengths, so the same 70-200mm lens works wonders. For the bigger group shots, I use the 24-70mm lens, depending on the amount of space I have. Then it is time for the reception; here, I use whatever lens gives me the best shot. I usually stick with one that gives me the wider view, except for the moments when I need to get closer and fill the frame with subjects like the cake cutting or the toasts.

Exposure Settings: I use Aperture Priority so that I can control the depth of field. This allows me to decide how much of the frame will be in focus and what the viewer will be drawn to look at in the image. Most of the time I am trying to make sure that the focus stays on the couple, so I tend to use a wide aperture and a shallow depth of field; but there are times, like with group portraits, or when trying to show how beautiful the location is, that you will want to go with a deep depth of field. When you go for a deeper depth of field, make sure that the shutter speed doesn't get too low. In such cases, you can easily increase the ISO to get the look you want.

Shooting Positions: Photographing a wedding will keep you busy! You need to be ready for all the different aspects of the event. The best way to prepare is to go to the location early and walk around so you know where things are going to happen. I have always thought that a great wedding photographer captures the event but does not distract from the couple. That means looking for the best angles to shoot the different elements without getting in the way (**Figure 7.19**).

Tips

- **Get help:** If you are photographing a wedding, get some help. There are so many things happening that a little help can go a long way. Having an assistant around to gather the people needed for the portraits, or even as a second photographer getting wide-angle photos of the ceremony while you deal with the close-ups, will definitely take some pressure off of you to be everywhere at once. Being an assistant to a wedding photographer, or even a second shooter, is a great learning opportunity. I would suggest that if you are serious about wedding photography, contact a local wedding photographer and offer your services as their assistant (**Figure 7.20**).

- **Make a list:** Make a list of the needed shots before the wedding and go over it with the couple. They might have a favorite uncle or cousin who needs to be in photos with them. Having a list means you don't end up missing anyone.

- **Plan the day:** Once a wedding starts, the day seems to fly by, so it is best to have a plan (or at least know what the wedding plan is). It will help you to know what is going to happen and when so you can make sure you have the right lens for the moment (**Figures 7.21** and **7.22**).

- **Look for reactions:** It is pretty obvious that at a wedding the bride and groom take most of the focus, but look for reactions to the big moments from other guests, especially family members. A great time for this is during the toasts, when everyone is pretty stationary and the attention is all on the same place. After you get the toast maker, look for reactions on the bride and groom, then on other people who might be moved. Laughter or tears—a great reaction will show emotion (**Figure 7.23**).

Figure 7.19 I stayed out of the way during the ceremony and took the majority of my photos from behind the guests so as not to disrupt the wedding. I was not the main photographer for this wedding so I did not have to get the main moments; I was tasked with getting the wider overall-view photos.

1/500 second; F/4.0; ISO 400

Figure 7.20 Having an assistant made this photo possible because they held the dress up for me to photograph against the blue wall. It's always a good idea to photograph the dress.

1/250 second; F/4.0; ISO 800

Figure 7.21 I scouted out places to take the portraits of the happy couple after the ceremony. This cut down on any wasted time since the wedding day can fly by.

1/180 second; F/2.2; ISO 1600

Figure 7.22 Knowing that the ring part of the ceremony was going to happen next allowed me to make sure I had a long lens ready to get the close-up the couple wanted.

1/50 second; F/2.8; ISO 400

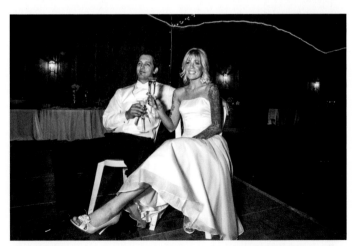

Figure 7.23 I positioned myself where I could see and photograph the bride and groom's reaction to the person giving the toast. The reaction shot is just as important!

1/30 second; F/5.6; ISO 1000

Concerts

Lens: Photographing concerts is tough due to the low light. Even the big concerts with lots of lights are still quite dark, so you need fast glass, such as lenses that open up to f/2.8 or even wider. The best lens for most concerts is the 70-200mm f/2.8 lens. Every camera manufacturer makes this lens and they are all great, but there are two big drawbacks. The first is the expense (these lenses can cost around $2,000); the second is the weight and size. The reason these lenses are so great for concerts is that they allow you to get in close (200mm) and still have a wide aperture that is great for low light.

Exposure Settings: When shooting concerts, the bright, moving lights can really throw off the camera metering systems. Here is how to get the best exposures even under difficult lighting: set the exposure mode to manual, the ISO to 1600, and the aperture to f/2.8. These are the base settings. You will need to adjust the settings after you take the first photo and see what it looks like on the monitor on the back of the camera. If the photo is too light, increase the shutter speed; if the photo is too dark, decrease the shutter speed until it is too low to freeze the action. Then increase the ISO and start the process over. Remember that you don't need the whole image to be in proper exposure—just the performer.

Shooting Positions: There are four different locations that just about all concert photos are taken from. The first is the photo pit right in front of the stage between the crowd and the band. This is still where most concert photos are taken. It is usually a crowded space and you need to be careful about your surroundings. The second spot is known as the FOH (Front of House), or behind the soundboard. This shooting position is located toward the back of the venue, in the middle. It's where the sound engineer and the lighting director sit. Shooting from back here means you need a long lens (usually a 400mm or longer) to get close. The third option is where most concert photographers started: in the crowd. Some venues allow you to

bring a camera in without permission so you can take photos from the crowd. The last place is from the stage, but that is reserved for a select few individuals who work directly with the bands.

Tips

- **Watch the light:** Concert lighting isn't random. It usually follows a pattern. Watch for the pattern so you can take the photos when the light is illuminating your subject (**Figure 7.24**). A good lighting director will have the music and the lights working together. If you want to capture the lights, drop the shutter speed a little to allow time for the lights to be exposed properly. It doesn't matter if the performers are overexposed here since the lights are the subject.

- **Shoot a sequence:** I shoot concerts in continuous drive mode so I can shoot a burst of images instead of a single frame. I like to shoot in bursts of three, especially when shooting in very fast-moving lights (**Figure 7.25**).

- **Watch the instruments:** A pet peeve of mine of when I see a photo of a musician playing a guitar and the headstock or the bottom part of the guitar is missing. I'm not saying I never do it, but I try not to do it unless absolutely necessary. Think of it this way: pretend you are photographing the show for the guitar manufacturer, and consider how they would want their instruments shown (**Figure 7.26**).

- **Check the backgrounds:** This one should be something we do at all times when making photos, but it really pertains to this category since many people get so focused on the musician that they forget all about the background.

- **Capture emotion:** Musicians in a concert are giving emotional performances. Make sure you're ready to capture that amazing shot when a performer has an interesting expression, or moves around the stage in an interesting way (**Figure 7.27**).

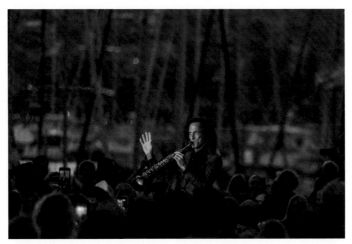

Figure 7.24 When the performer started out in the audience, I needed to watch how the light illuminated him.

1/2500 second; F/4.0; ISO 800

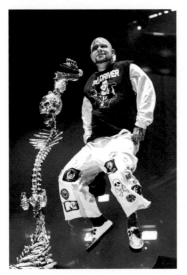

Figure 7.25 This shot was not luck or a fluke; I saw the singer start to jump up and down and shot a sequence of five images to capture him in midair. It looks like he is floating!

1/250 second; F/2.8; ISO 1600

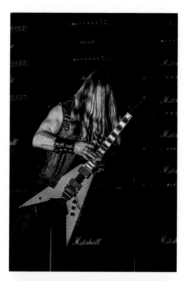

Figure 7.26 I made sure that the guitar was not cut off in any way, and waited until the guitarist was right in front of his amp, which made a great background.

1/250 second; F/2.8; ISO 1600

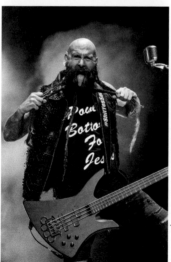

Figure 7.27 Split-second reflexes are necessary. When a performer gives you a look, you need to be ready to take advantage of a unique photographic opportunity.

1/320 second; F/2.8; ISO 1600

Secret Weapons

Lens rental: Need to shoot an event and you don't have the right lens? Don't buy a lens for a single shoot—rent first. There are numerous online camera rental places and most cities have a camera store with rental options. For more information, check out the Secret Weapons section in chapter 6.

Telephoto extenders: These devices, known as telephoto extenders, multipliers, and telephoto converters, fit between the lens and the camera body to extend the reach of the lens. They come in different strengths—for example, the Nikon versions come in 1.4x, 1.7x, and 2x versions. The advantage to these converters is that they extend the effective focal length of the lens at a much lower cost. There is another cost to using the telephoto converters: loss of light through the lens reduces the widest usable aperture by up to two full stops. To use them effectively, you need to either be shooting with plenty of light or you need to really raise the ISO. Check with your camera manufacturer for compatibility with your camera model and lens.

Advanced Tips and Tricks

If you want to take it up a notch, here are some skills you can work on. These tips and tricks are more advanced, and it helps to understand the basics first.

Play with slow shutter speeds: Once you have mastered freezing the action when shooting events, try dropping the shutter speed just a little so you get some motion in your images. For example, I will try to get a blur in the drumsticks when photographing a drummer to show the motion of the action (**Figures 7.28** and **7.29**).

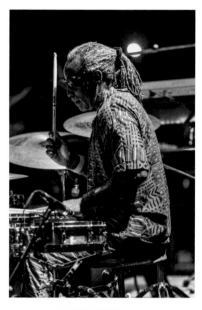

Figure 7.28 The drumstick is frozen in place due to the shutter speed used on this shot.

1/250 second; F/2.8; ISO 3200

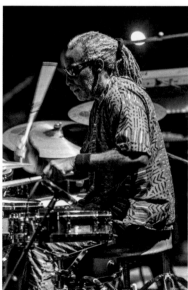

Figure 7.29 Dropping the shutter speed to 1/200 got a little blur in the fast-moving sticks, but kept the rest of the image sharp. The slight bit of motion makes this image much more compelling because you know he is putting on an energetic performance behind the drum kit.

1/200 second; F/3.2; ISO 3200

PRACTICE

Give This a Try

If you have a friend or family member in a performance of any kind, reach out to them and see if you can come to (and take some photos at) a rehearsal. Practice being a fly on the wall. (If you want to make friends, offer to give your subjects prints of your best shots after the event.)

Give This a Try

Check out your local event guide to see what is going on in your town, and go photograph something fun. To start out, shooting a daytime event will be less challenging.

Take It a Step Further

If you really want to learn concert photography, hang out in a local bar or small music venue. It is much easier to get permission to shoot a small local band than it is to shoot a big national act. There is also a serious advantage to learning this kind of photography by shooting in really low light: when you do get to shoot a show with better lighting, it will be really easy to get great photos.

Notes

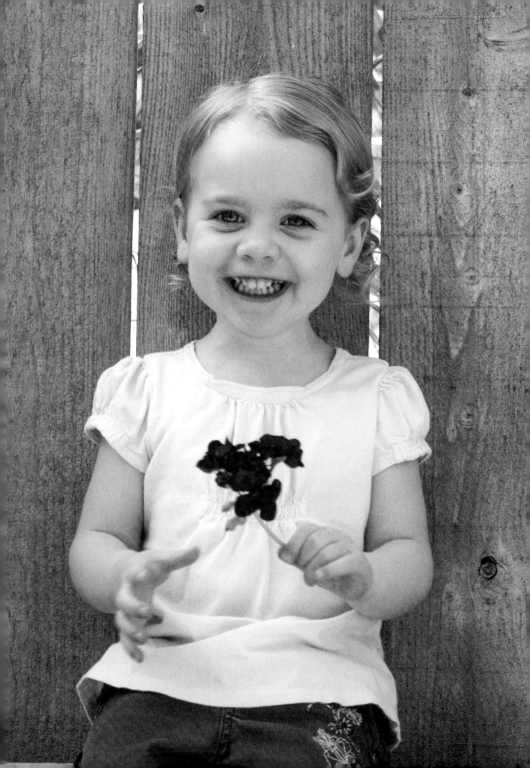

PHOTOGRAPHING PEOPLE

People make great subjects for photos. From candid photos to posed portraits, getting a great photo of someone isn't that difficult if you stick to the basics. This chapter is going to cover the different types of lighting and how you can modify it to suit your purposes.

The Different Types of Lighting

There are different types of light available to photographers, including available (ambient) light and light that you bring to the scene. Available light is any light that is already present in the scene, from the sunlight streaming in through a window to the overhead fluorescent tubes in a locker room. The other type of light is what you bring to the scene, like a flash, studio strobe, or even an LED light panel. Let's look at using both types of light to take photos of people.

Using Available Light

Available light is any light that is already in the scene. This makes taking the photo easier because all you have to do point the camera at the subject and take the photo. Here is what to look for when taking an available-light portrait.

- **Start with the location:** The location of the shoot is really important. You are looking for a spot that has a simple background and soft, indirect lighting, which prevents distractions and keeps the attention on the subject (**Figure 8.1**).

- **Open shade is your friend:** Open shade means your subject is in a shaded area with soft light from indirect sunlight. When a person is posed in direct sunlight, parts of their face will be very bright, but there will be sharp (and deep) shadows. When placed in open shade, the light is more even, making the transition between light and dark areas in the photo more subtle for a pleasing, natural look (**Figures 8.2** and **8.3**).

- **Look at the direction of the light:** Where is the light coming from? Are you taking a photo at noon with the sun directly overhead or is it late in the afternoon with the sun coming from the horizon? Knowing where the sun is coming from and where the subject is allows you to control where the shadows fall and how the subject is portrayed. The sun directly overhead can cause shadows under the eyes that can make your subject seem dark and lifeless, while the warm light in the late afternoon can make your subject seem rosy-cheeked and healthy. If you're not sure about the direction of the light, hold your hand up and see which part of it is lit and where the shadows fall.

- **Change metering modes:** Since you are shooting with available light, you can use the camera's metering system to get the proper exposure. The key here is to pick the right metering mode for the situation. The easiest way to do that is to take a photo with each of the metering modes and see which one you like the most.

Figure 8.1 Not all portraits have to be posed. I photographed Cameron as he played guitar in the shade from the tree. The f/3.2 aperture was enough to blur the background and have him stand out.

1/2000 second; F/3.2; ISO 400

Figure 8.2 I photographed this costumed character in the shadow of the building in the late afternoon. The even light meant no harsh shadows or bright spots on the armor.

1/1000 second; F/2.8; ISO 800

Figure 8.3 This group posed for photos during a local Día de Muertos celebration. They were positioned right under the porch overhang, which created great light (open shade).

1/250 second; F/5.6; ISO 400

Using a Flash

There are times when available light just isn't going to cut it. It could be too dark, or it might be plain ugly. In these situations you need to bring your light, and a flash is the easiest light to bring to a shoot. Every camera manufacturer makes a small flash that can be used right on the camera. They slide into the hot shoe on the top of the camera and, when turned on, they fire when the shutter release button is pressed. They are small, light, powerful, and relatively inexpensive, making them the perfect accessory. The downside is that many people don't like the results they get when the flash is aimed right at the subject, so they stop using it and stick to available light. The key to using a flash is to get it to mimic natural light, which is tough because of the position of the flash on top of the camera. With the flash aimed at the subject, the light is blasting straight at them, which is not a very flattering look. Here is what you need to know about using your flash:

- **Sync speed explained:** When you take a photo with a DSLR, the mirror has to move up and out of the way. The front shutter opens and stays open for the amount of time determined by the shutter speed; then the rear shutter closes. This works great for shutter speed of 1/200 second and slower, but at higher shutter speeds the rear shutter starts to close before the front shutter is open all the way (**Figure 8.4**) This means that if you fire the flash when using a shutter speed higher than 1/200 second (I know on some cameras it is 1/250 second) the flash cannot illuminate the whole scene. In such cases, there are two options. The first is to use a slower shutter speed. The second is to use high-speed sync, in which the flash fires multiple times as the front and rear shutter move across the sensor. This is why most cameras do not allow you to pick a faster shutter speed when your flash is on your camera unless you turn on high-speed sync. For this book, we are going to stick with the normal sync speeds of 1/200 second or slower.

- **Shutter speed controls the ambient light:** When you take a photo, the longer the shutter is open, the more light is allowed to reach the sensor. As you increase the shutter speed, less ambient light has time to reach the sensor. This is useful when taking photos with a flash because the shutter speed can control how much of the ambient light is recorded. Longer shutter speeds mean more ambient light, shorter shutter speeds means less ambient light. Because the flash is lighting the subject, the amount of ambient light in the shot will change how the background looks—but not how lit the subject appears. You can see in **Figure 8.5** what a fast shutter speed does to the ambient light (it made the ambient light go away, resulting in a dark background).

- **Rear curtain sync:** The camera can fire the flash right as the first shutter opens or you can use rear shutter sync. Rear-shutter sync fires the flash right before the rear shutter closes. This works best with slower shutter speeds. Note that this mode does show some movement of the subject.

- **Understanding fill flash:** The most useful aspect of using a flash is being able to add a touch of light to fill in the shadowed parts of an image. To use fill flash effectively, you need to learn how to turn down the power of your flash (check the camera and flash manuals for this information). The idea is to make the photo look natural—not lit with a flash.

- **Angle the flash:** The simplest way to get better photos with the flash on the camera is to angle the flash head over the subjects so the light bounces off the ceiling (if there is one). The reflected light will be softer and more natural looking. This can also work without a ceiling if you have a diffusion dome on the flash. A diffusion dome will angle some light toward the subject, but most of the light will be soft and diffuse so it doesn't look like all the light came from the camera position (**Figure 8.6**).

Figure 8.4 At higher shutter speeds, the rear shutter starts to close before the front shutter is open all the way.

Figure 8.5 I eliminated all the ambient light by using a flash and a shutter speed of 1/200 second. This allowed me to get this photo of Jennifer as if there were a black background behind her. If the room was more brightly lit, I would have had to use a higher shutter speed and high-speed sync flash.

1/200 second; F/5.6; ISO 100

Figure 8.6 I used a flash for this photo of actor Blair Redford, but I aimed the flash over his head and used a diffusion dome. This gave me a more natural-looking photo that doesn't have a "flash-photo" look.

1/100 second; F/5.6; ISO 800

Soft Light Versus Hard Light

Hard light is created by a small, bright light source and is easily identified by the hard-edged shadows it creates. A great example of a hard light source is the sun. Now I know you are thinking that I am contradicting myself because I just said a hard light source is small, and everyone knows the sun is huge. The size of the light source is affected by distance, so think of it as the relative size of the light source in relation to the subject: the sun is really big, but very far away, making it a relatively small light source in relation to your subject. On the other hand, the relative size of a softbox placed right next to your subject is quite large. For the best soft light, you want a large, diffuse light source close to the subject. For example, placing a person in the light from a window works well.

To see the difference between hard and soft light, just take a look at **Figures 8.7** and **8.8**; the first was taken in direct sunlight, and the second was taken under the shade of a nearby tree. The difference is easy to see.

Figure 8.7 The hard light of direct sunlight causes deep shadows and bright spots on the cheeks.

1/320 second; F/8; ISO 200

Figure 8.8 The soft light in the shade is much more pleasing, and doesn't cause harsh shadows.

1/90 second; F/5.6; ISO 200

Lighting Modifiers

Being able to control, or at the very least, modify the light gives you options in your photography. You can break lighting modifiers into three different groups: modifiers that the light passes through (diffusers); modifiers that bounce the light (reflectors); and modifiers that change the shape of the light (grids and snoots).

Diffusers

A diffuser is anything that is placed between the light source and the subject that changes the amount of light illuminating the scene. This could be a small diffusion dome on the head of a flash (as seen in **Figure 8.9**) or a large piece of semitransparent material held between the light source and the subject (**Figures 8.10** and **8.11**). The job of a diffuser is to soften the light by creating a larger light source closer to the subject. Diffusers come in many different styles, with umbrellas, softboxes, panels, and dome diffusers being some of the more common types.

- **Umbrellas:** These umbrellas are made with a translucent material that the flash or strobe is fired through.

- **Softbox:** A softbox is a box made out of black material that does not allow any light through except for the front panel, which is translucent. Softboxes are made for use on artificial lights, such as a studio strobe or a small flash unit. The construction allows you to control the direction of the light with greater accuracy than an umbrella. Softboxes come in a huge variety of styles and sizes, depending on the size of the light it is designed for. You can even get some very small softboxes that attach to a flash mounted on your camera. You can see a small softbox attached to a Nikon speedlight in **Figure 8.12**.

- **Diffusion panel:** A diffusion panel is a piece of translucent material attached to a rigid frame that you can hold between any light source and the subject. They come in a variety of styles and strengths. For more on these, check out the secret weapons section later in this chapter.

- **Dome diffuser:** These fit over the head of your flash. They bounce the light around inside the diffuser before sending it out in all directions, creating a softer light. Many small flashes come with these, but if yours didn't or it got lost, you can buy a replacement, such as the Omni Bounce from Sto-Fen.

Reflectors

Anything that bounces light can be used as a reflector. It could be a professionally made reflector or the big white wall next to your subjects. The idea is that you are taking a small light source, like the flash, and creating a bigger (softer) light source through its reflection. Reflectors come in a variety of different colors because the color of the light will change depending on the color of the reflector. Here are some common reflector colors and what they do to the color of the light.

Figure 8.9 This plastic diffusion dome does a great job of diffusing the light. The light bounces around inside the dome and is diffused when it hits the scene.

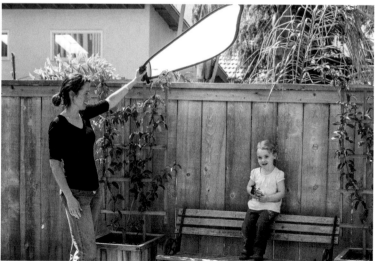

Figure 8.10 Here, you can see a mom holding a TriGrip 1-stop diffuser over her child to help block the direct sun, creating a much softer light for the photo.

Figure 8.11 The diffuser yields a nice, soft light for this image of the child.

1/125 second; F/5.6; ISO 200

Figure 8.12 You can get really small softboxes that fit on portable flash units.

- **Gold:** A gold surface creates a warm light that is meant to mimic early-morning and late-afternoon sunlight. The light from the gold reflector can be very red and sometimes too warm if used during a sunrise or sunset. I don't use gold reflectors very often.

- **Silver:** The silver side of the reflector bounces a huge amount of light and gives it some punch. You just have to be aware that the bounced light from the silver surface could overpower the main light (seen in **Figure 8.13**).

- **White:** White reflectors bounce less light than the gold and silver surfaces, and they don't change the color of the light. The light bounced from the white surface can add a nice, even light to a portrait and reduce hard shadows. You can use a white wall, a piece of white board, or any other large white surface to bounce the light.

- **Combination colors:** Some reflectors come with two sides: either a combination of white and silver or white and gold. These combination reflectors tend to have toned-down versions of the gold surfaces and silver surfaces.

Grids and Snoots

These devices fit over the light source to limit it in some way. These are used with small flashes and studio strobes to control where you want the light to reach and where you don't. These devices are all about limiting where the light is going. They allow you to selectively light your subject. A snoot is just a fancy word to describe a tube that goes over the flash head to keep the light more focused on the subject (**Figure 8.14**). A grid is a smaller device that doesn't stick out far from the flash head (like a snoot can). It controls the spread of the light by using small tubes (like a bunch of drinking straws) all packed together, keeping the light constrained (Figure 8.14).

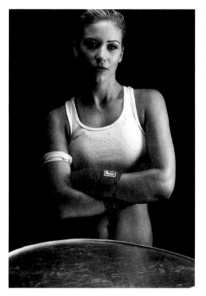

Figure 8.13 The silver reflector can be seen at the bottom of this image. It was used to bounce some of the light up into the face of the model.

1/250 second; F/9.0; ISO 100

Figure 8.14 A snoot and a grid over the head of a Nikon speedlight.

The Starting Point

Portrait lens: If you want to get confused, try searching for the best portrait lens on the internet. There are a lot of opinions out there! In reality, the best lens depends on what you want to show in your photograph. When it comes to choosing your lens, be aware of how different focal lengths render people in your portraits. For a refresher on the effects of the different focal lengths, look at page 93 in chapter 4. Figures 4.15–4.18 show what happens to the background when different focal lengths are used. **Figures 8.15–8.17** show what happens to a person's face when we use different focal lengths. As you can see, the longer focal lengths are more natural and flattering. So while it's true that you can use any lens for photographing people, I suggest you start with a focal length of 70mm or longer.

Figure 8.15 This photo was taken at 24mm. As you can see, there is distortion in the photo and the things closest to the lens seem bigger.

1/250 second; F/4; ISO 400

Figure 8.16 This photo was taken at 70mm, and as you can see, the person now looks more normal without any distortion in the image.

1/250 second; F/4; ISO 400

Figure 8.17 This was taken at 200mm and the face looks natural without any distortion. You can also see that there are leaves in the background.

1/250 second; F/4; ISO 400

Exposure mode: I shoot 99% of my portraits in aperture priority mode or manual mode so I can control the depth of field and make sure that the focus is correct. Don't use too wide of an aperture when shooting in close with a long lens, because the depth of field might end up so shallow that the eye is in focus but the tip of the nose is not. When shooting group photos, use a deeper depth of field and place the focus point 2/3 of the way into the frame so everyone is in focus (**Figure 8.18**).

Focus: This one is critical. You need to make sure that the eyes are in focus. I cannot stress this enough. If the eyes are out of focus, the photo will never be great. I use a single autofocus point right on one of the eyes of the subject (**Figure 8.19**).

Figure 8.18 For this group shot, I made sure that I used a deep depth of field. I set the focus on the middle row of people so that the people behind them and in front of them would all be in focus.

1/80 second; F/8.0; ISO 800

Figure 8.19 I used spot metering on the subject's face and aperture priority exposure mode. I made sure that the eye was in focus. The low angle and longer focal length (105mm) makes for a pleasing image.

1/160 second; F/5.6; ISO 100

CASE STUDIES

Environmental Portrait

An environmental portrait is one that is taken in a location with special meaning for the person in the photo. It might be a portrait of the person in their office or workplace, or it could be of them doing something they love (**Figures 8.20** and **8.21**). These portraits tend to show off the personality and lifestyle of the subject more than a traditional portrait. You can see environmental portraits everywhere, from magazines to social media profile photos.

An environmental portrait is taken on location, and you need to make sure that the location adds to the image without being distracting. The basics of composition still apply—make sure the exposure is good and that the focus is on the eyes, and make sure that the depth of field is deep enough that the surroundings are recognizable and in acceptable focus.

Lens: Use a focal length that allows you to capture both the person and enough of the environment to tell the story. I prefer to use a longer focal length and shoot from farther away, but don't get hung up on a particular lens—use what works for your shot in the environment.

Exposure mode: I use aperture priority and shoot with enough depth of field so that both the subject and the environment are shown.

Focus: Focus on the eyes. Always focus on the eyes.

Here are some tips on shooting an environmental portrait:

- **Research:** You need to know a little about the person whose portrait you are taking and why the location they choose is important. You can do some research beforehand, but the best way to familiarize yourself with the subject is to ask them about their story.

- **Try Live View:** Most of today's DSLR cameras have a live view that lets you see the image on the back of the screen instead of through the viewfinder. This is helpful because many people tense up when a photographer raises the camera to their eye. This way, you can keep the rapport going with the subject as you glance down at the view screen.

- **Collaborate:** Ask the subject if they have any ideas. Is there something fun they want to try? The subject will be more invested in the photos if they have some input.

Figure 8.20 My buddy Andy loves to ride his mountain bike, so it seemed fitting to take a portrait of him on his bike at the start of a trail.

1/2000 second; F/2.8; ISO 400

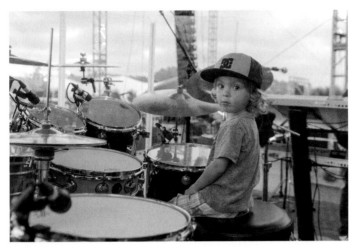

Figure 8.21 I love this photo of a future drummer. When I saw this kid climb up behind the drums, I knew I had to get this photo. It would have been easy to zoom in closer, but the setting was important to tell his story.

1/320 second; F/2.8; ISO 1600

Indoor Portraits

The challenge with photographing people inside is the potential lack of (or poor quality of) light. You either need to have natural light coming in through a door or window, enough available light from lamps or overhead lights, or you need to bring your own light. Many times an indoor portrait can use a combination of available light and some flash.

Lens: When shooting inside and using a flash, remember that the flash has limited power and won't reach the subject if you are not shooting from too far away. Also, the flash is on the camera, so when using a long lens, the farther away you are, the smaller the light source of the flash becomes; thus, the harder the quality of that light. Many of the indoor portraits I take are shot using a 24-70mm lens, and I try to stay closer to 70mm (**Figure 8.22**).

Exposure mode: I use aperture priority mode with a deep-enough aperture to get the person in focus. I will increase the ISO so that the flash doesn't have to work so hard.

Here are some other tips to help with indoor portraits:

- **Flash on camera:** If you want to take photos of people inside, at some point you are going to have to use a flash. I suggest buying one and practicing with it at home so you are familiar with the controls and how it works. The most important thing your flash head needs to be able to do is tilt and rotate so you can aim the flash independently of where the lens is pointing.

- **Bounce light off the ceiling:** Look for large surfaces above and to the sides of your subject when photographing a person (**Figure 8.23**). These can be used to bounce the light. If there aren't any surfaces and the ceilings are very high, that's when I use my secret weapon: the Rogue FlashBender. More on that later in the chapter.

- **Look for windows:** Window light is great, if you can find it. Look for light coming in through the window, then place your subject just in the edge of the light (you don't want everything to be blasted with diffused sunlight!).

- **White balance is key:** When you shoot inside, chances are there will be a mixture of lighting types that might yield weird colors (**Figure 8.24**). Check the manual for directions on how to set a custom white balance for your camera. One quick way to see the best white balance for your scene is to turn on the live view, look at the monitor on the back of the camera, then start to cycle through the white balance settings and see which one looks the best. Check your camera manual for instructions on how to adjust white balance, but usually you press the White Balance button and rotate the main dial. The camera will show the current scene on the back of the camera with the different white balance settings applied, so you can easily make a choice as to which one you like.

Figure 8.22 This photo of actor Mark Christopher Lawrence was taken with the camera flash. While the light isn't very hard, it isn't very soft, either. This is due to the small size of the flash and how close I was to Mark when I took the photo.

1/180 second; F/5.6; ISO 400

Figure 8.23 It's always great to photograph someone who has just won an award. For this photo, taken during a large conference, I looked for a backdrop that would give some meaning to the photo. I aimed the flash over the subjects' heads and bounced the light from the ceiling.

1/125 second; F/5.6; ISO 1600

Figure 8.24 This portrait of Kevin and Jason was taken during their appearance at a comic-based event. This photo is lit with a combination of the different types of lighting in the room, including the lighting used to illuminate the poster they are standing in front of and some fill flash from the speedlight on my camera. I had to be careful to only use partial power on the flash so the photo wouldn't be overexposed. I used spot metering on their faces combined with aperture priority and reduced the power from the flash to 1/4.

1/80 second; F/6.3; ISO 800

Outdoor Portraits

Photographing outside can be a lot easier than photographing inside because of the availability of light. The issue outside, however, is that there can be too little or too much light. The best time to shoot portraits outside is when there is cloud cover that diffuses the sunlight. But if you plan to shoot outside under clear, bright skies, make sure your subjects are in the shade (**Figures 8.25–8.27**).

Figure 8.25 I photographed these sisters in the shade of a tree in their backyard. To help with the light, I had an assistant hold a diffuser so there were no bright spots from the sun. I used matrix metering and put the focus spot right on the eye of the sister on the left.

1/125 second; F/4.5; ISO 200

Figure 8.26 Photographing Mia in the local park was tough because it was the middle of the day and there were no clouds in the sky. I placed her as close to the hedge as possible and used a shallow depth of field to get this portrait. You can see the setup in Figure 8.27.

1/200 second; F/3.2; ISO 200

Figure 8.27 Here, you can see how bright the day was and where I placed Mia to get the best results.

Group Portraits

A group portrait might be the most difficult type of portrait to take due to human nature. It is very difficult to get everyone looking at the right place with the right expression at the same time. The more people in the group, the more difficult it becomes.

- **Get their attention:** This might be the hardest skill to accomplish in this whole book. It is nearly impossible to get everyone's attention at the same time. I usually have to shout to get (and hold) their attention while I take the photo.

- **Take a series of photos:** Don't take just one photo and hope you got the best shot. A better bet is to take a series of photos in quick succession and hope that everybody is looking at you in at least one of the shots (**Figure 8.28**).

- **Stairs are a gift:** One of the issues with group photos is that it's difficult to layer and stagger people in lines and still see everyone, especially people in the back. Stairs are a great way to give the people in the back rows a bit more height. As you can see in **Figure 8.29**, I shot this group on stairs. It works great; just make sure the depth of field is deep enough to get everyone in focus.

- **Use fill flash outside:** One of the more difficult photos to take is when the group is backlit and their faces are in in deep shadow. One way to solve the issue is to move the people, but if that isn't possible, a little touch of fill flash can really make the photo look more natural and open up the shadows. The secret is to set the flash to manual power and only use a little power. In **Figure 8.30**, I used a touch of fill flash to lighten up the riders because we wanted to keep the water at their back.

Figure 8.28 In this huge group, some people are not looking at me (or even anywhere close to my direction). I made sure my focus was in the middle of the group and used a very deep depth of field to make sure everyone was in focus. The seagull flying overhead was just luck.

1/250 second; F/11; ISO 400

Figure 8.29 A staircase can be very helpful in making everyone visible in a big group shot.

1/25 second; F/11; ISO 1600

Figure 8.30 A smaller group shot outside after a ride. I had to make sure that they were all in focus and that the bright sky didn't cause the shot to be underexposed. When you have an area of very bright sky, the camera will try to compensate by making it darker, and in doing so, will make the subject darker as well. I added a touch of flash to create a more balanced exposure.

1/200 second; F/10; ISO 640

Secret Weapons

5-in-1 reflector/diffuser: A piece of gear that makes my life a lot easier when taking photos of people is a combination reflector and diffuser. It's a reflector with three different reflectors (gold, silver, and white), a diffuser, and a solid black flag that can stop light from going where I don't want it. There are numerous versions of this all-in-one reflector that can range in size and cost.

You can get a 40" collapsible version for $40, a great deal for how useful it is.

Rogue FlashBender: Another piece of gear I use is the Rogue FlashBender. This is a large, flexible piece of nylon that attaches to the head of a small flash unit and acts as a bounce card. The light can be bounced off it to create a larger, softer light right on your camera. I used a FlashBender in **Figure 8.31** (the group shot) and in **Figure 8.32**,

where it was attached to my Nikon Speedlight and used to create soft light for the portrait of musician Bill Bell.

Figure 8.31 For this image, I had to make sure the whole group was in focus, and I had to light them with a small flash. I used the Flashbender and increased the power of the flash to light up everyone from the front to the back. I used an aperture of f/11 to get a deep depth of field. I also had to make sure I was ready to go because I only had about a minute to take this shot.

1/60 second; F/11; ISO 1600

Figure 8.32 Musician Bill Bell photographed in a recording studio. There really wasn't much room to work and the lighting was very dim. The FlashBender really helped make the light bigger and more pleasing.

1/80 second; F/2.8; ISO 1600

PRACTICE

Give This a Try

Being comfortable behind the camera when photographing people takes practice. Start by taking photos of your friends or family members at home, but keep it short so your subjects don't get bored and you don't get frustrated. Keep it light and fun.

Give This a Try

Practice with a flash before you actually have to use one so you know your photos will look good when you want to get great shots at an important event. Grab a friend or family member and pose them outside in the shade, and use the flash to add light. Practice getting a good balance between the natural light and the flash light to light the subject evenly. Adjust the power of the flash (check the flash and camera manual for the controls that do this) until the portrait looks natural.

Take It a Step Further

Get a diffuser, grab a friend, and work on getting photos in both soft and hard light so you can see the difference it can make to a portrait. Place your subject outdoors in the bright, hard light of the midday sun. Set the camera to Program Auto or Auto mode and take a photo. Next, have a friend hold the diffuser between the sun and the subject to block the direct sunlight, and take a second photo. Take hard-light and soft-light photos in the different metering modes to see how it affects the look of your subject.

Notes

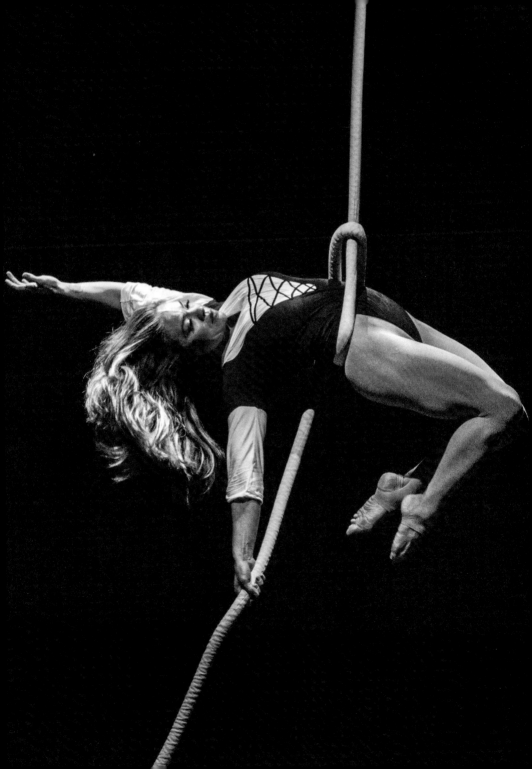

SHARING YOUR IMAGES

Taking photos is a lot of fun; sharing your photos with others is even better. In the old days, you dropped off your film and got back a set of negatives and a set of prints. You could send the prints to a friend or family or put them in a frame on display in your house. Then the internet came along and digital photography took over. Now we share our photos via email, or by posting them on Facebook, Instagram, Flickr, 500px, or your own website or blog. There are more than 300 million photos being posted to Facebook each day. That's a lot of photos. Let's look at the best way to share some of your photos.

The Best File Format to Use

Your camera can save the images it captures using two different file types. The first type is a JPG, or JPEG, file. This is as close to a universal photo file format as we have. JPG files are easily viewed on the internet, can be seen in email programs, can be printed, and can be used just about everywhere. The other type of file is a RAW file. The RAW file captures all the data from the camera sensor, but it needs to be processed (converted into a JPG) using software before it can be posted, emailed, or shared.

Why You Should Probably Photograph Using JPEG Files

The two best reasons to use the JPEG file type is that the files are smaller and ready to use right from the camera. Many times I shoot sports using the JPEG file type because it is faster, takes up less space on the memory card, and editing is usually minimal. I suggest that everyone start out using the JPEG file type because it is easy to use.

Once you decide to start using RAW, check to see if your camera has the ability to save each file as both a RAW and a JPEG. That way you can use the JPEG immediately and still have access to the RAW file if you want to edit it later. This takes more memory-card space and can slow the camera down because it has to write two files each time you take a photo.

When to Consider RAW

The RAW file contains all the data from the sensor. The amount of data in the RAW files allows for a lot of editing potential in post-production. You can change the white balance and the exposure, and you can edit the bright and dark parts to show more detail. It's actually quite amazing what you can do with a RAW file. The downside is that you have to edit the photos before you are able to use them. Check out the two images to see what is possible. I purposely pushed the editing to the extreme to show what can be done with a RAW file (**Figures 9.1** and **9.2**).

Figure 9.1 The RAW file. The lighting for this performance was really dark and I ended up underexposing some images. Had I shot them in JPEG, it would have been tough to fix them in post-production. I used Adobe Camera Raw (part of Photoshop) to edit the image, and ended up with the photo in Figure 9.2.

1/250 second; F/2.8; ISO 1600

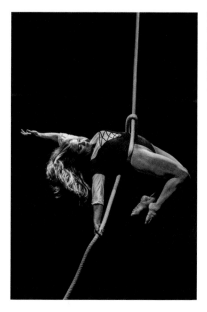

Figure 9.2 As you can see, the edited version of the image has a lot more detail than the original. This extreme editing would not have been possible if this was a JPEG file to begin with.

1/250 second; F/2.8; ISO 1600

Five Edits You Can Make on Your Smartphone to Get Better Images

Forget the computer for a while. Let's talk about the editing you can do with your smartphone or tablet. These devices have come a long way and the photo-editing capability is astounding. I am going to use the Snapseed app for the following example edits. Snapseed is a photo-editing app created by Nik software (which was bought by Google). It is available for both Android and iOS devices. The screen shots used here are from the iPhone version.

All of these edits can easily be made using image-editing software on a tablet or computer.

Cropping

The first thing I do with my photos is crop them if needed. This is especially useful if you are posting them to social media. Since most people look at social media on their smartphones, the photos look

pretty small. Cropping to eliminate anything in the photo that is not important is helpful. In the following images you will see the original photo, then the editing screen for the Snapseed app, and then the final photo.

- Open the photo in the app (**Figure 9.3**).

- Select Tools from the bottom, and then select Crop (**Figure 9.4**).

- Use the crop handles to crop the image.

- Press the check mark to accept the changes (**Figure 9.5**).

Adjusting the Exposure

To adjust the exposure of the image, click on the Tools and open Tune Image. There are a lot of different controls here to help adjust the exposure. For this image, I increased the brightness to +83, which really lightened up the image. Then I increased the contrast to give the image more pop (**Figure 9.6**).

Figure 9.3 The original shot open in Snapseed.

Figure 9.4 The crop dialog.

Figure 9.5 The cropped image.

Figure 9.6 The edited image with the brightness increased to +83 and the contrast increased to +56. These are not magic numbers; you can increase or decrease the brightness and any other exposure control as you see fit.

Better Color (White Balance)

Snapseed allows you to fix any color casts by picking the White Balance tool and using the eyedropper to click on a spot in the image. The color for the whole image will be adjusted (**Figure 9.7**).

Figure 9.7 Snapseed allows you to use the eyedropper to click on an area of neutral color. The White Balance will adjust the color for the whole image. You can experiment by clicking around the image to see what looks the best to you.

Vignette

A vignette darkens the outside edges, which keeps the attention on the elements in the middle of the image. Too much vignetting can make the image look fake, but a little can look quite natural—and it really does keep the attention in the center of the frame (**Figures 9.8** and **9.9**).

Figure 9.8 A vignette darkens the outside edges of the image. You don't want to go too crazy with this one. Here, you can see the vignette set to 100, which is just too much.

Figure 9.9 Here, the vignette is reduced and the image looks more natural.

Sharpness / Clarity

The last step before exporting the new image is to add a little sharpening. This just makes the image look more in focus and, well, sharper. I apply both structure and sharpening, but not a huge amount of either. I don't want the image to look too sharp or fake (**Figure 9.10**).

Figure 9.10 The final step is to add some structure and sharpening.

After the image is saved, it is ready to be shared via email or posted to your favorite site.

In **Figure 9.11**, you can see the original image, and **Figure 9.12** shows the image after the edits. There was nothing really wrong with the original image other than being a little dark; but as you can see, a little cropping and a few minutes of quick edits resulted in a much better photo. Take a minute to edit your images before sharing them.

As a final word, something professional photographers do that makes it look like every photo they take is a spectacularly great one is to only post a couple of images—and they make sure to post the best ones. If you look at the portfolios or social media feeds of photographers like Joe McNally, Joel Grimes, and Glyn Dewis, you will see that they all have something in common: they don't post a lot of photos, but the photos they do post are all great.

Figure 9.11 The original image.

Figure 9.12 The final image after the edits.

PRACTICE

Give This a Try

This one is easy, because everyone loves their smartphones and the available apps! Pick a photo-editing app and work on editing one of your images. Start easy by cropping the image to see if you can make a more effective composition.

Take It a Step Further

There is a whole industry built around photo editing and image manipulation. If this is something you are interested in, you'll want to look into learning how to use editing software like Adobe Photoshop. Photoshop is a massive, complicated, steep-learning-curve type of program. I recommend getting a good book on the subject, such as The Photoshop Toolbox by Glyn Dewis (https://rockynook.com/shop/photography/the-photoshop-toolbox/). It will get you started with this great piece of software.

Notes

THE INSIDER'S GUIDE TO PHOTOGRAPHY TERMS

Every discipline has its own insider's language, and photography is no different. Photographers have a lexicon of terms to describe techniques, gear, and accessories, and this can make outsiders feel confused. Here is a list of words and terms that will allow you to understand what other photographers are talking about.

Bokeh (Boke-uh): This term refers to the out-of-focus areas in a photo (especially when using a very shallow depth of field).

Brad's Beard: My good friend and talented photographer, Brad Moore, who has been the first assistant to both Joe McNally and Scott Kelby, grew a beard that gained a following in the photography community and I wanted to give the beard a mention here. It is an inside joke that you are all now privileged to know.

Chimping: The act of checking out your photos on the back of the camera. There is a negative connotation to this word; it conjures a scene where the photographer acts excited as they look at what they just captured. Actually, the ability to immediately review your shots is one of the best things about digital photography, and you should check the images on the back of the camera to make sure you have captured what you wanted.

DoF / Depth of Field: The area both in front of and behind the focus point that is in acceptable focus. A deep depth of field means a lot of the image is in focus while a shallow depth of field means that a narrow area is in acceptable focus.

Dragging the Shutter: This describes the process of using a slower shutter speed than necessary, combined with a flash, which allows more ambient light to illuminate the photo.

Flag: Any device used in photography to block the light. A flag goes between the light source and the subject.

Fps (Frames Per Second): The number of images the camera can take in a row during one second.

Full Frame/Cropped Frame: The sensors in digital cameras come in a variety of sizes. Either they are the same size as a 35mm piece of film (full frame) or smaller than a 35mm piece of film (cropped frame).

Gearhead: This term describes a person who is very interested in the gear associated with photography. They tend to have the latest and greatest gear, and may know more about it than how to apply it to their photography.

Gigs: A shortened version of gigabyte, the unit that describes the capacity of your memory card. A 64-gigabyte memory card would be referred to as 64 gigs.

Glass / Fast Glass: A "glass" is a lens. Photographers use this term because good lenses are made with glass, not plastic. A "Fast Glass" is a lens with a wide maximum aperture (lenses with an f/4 or wider maximum aperture are considered to be fast lenses).

ISO: The standard that measures the sensitivity of film to light. It is now used to determine how the digital sensor in the camera amplifies this signal. This allows the sensor's light sensitivity to be treated in a uniform manner.

Macro Lens: A lens designed for close-up work. A true macro lens has a very close minimum focusing distance and allows you to get a 1:1 capture, meaning the image captured on the sensor is the same size as the subject in real life.

Motion Blur: Streaking or blurring in a photo in a direction that shows the movement of the subject in the frame.

Noise / Digital Noise: Digital noise describes the little specks of random color that appear in an image when you use a high ISO setting or a long exposure time.

Pixel Peeping: This is a derogatory term referring to people who examine the photo at the pixel level, looking at the fine details instead of looking at the overall photo.

Rule of Thirds: One of the most basic compositional "rules" in which you divide the scene using a grid of two parallel vertical lines and two parallel horizontal lines (like a tic-tac-toe board), then place the subject at one of the four points where the lines intersect.

Seamless: This is a type of backdrop used in photography, usually a roll of paper. Seamless paper comes in a wide variety of colors and lengths.

Shooting Speed: Another term for shutter speed—the amount of time the shutter is open.

SOOC (Straight Out Of Camera): This term denotes that you have not edited the photo in any way; it is being shown exactly how you captured it, straight out of the camera. No post-production, no editing, and no Photoshop. I've found that you cannot actually get an image just how you want it without editing of some type. Either you edit the image with the settings you use in the camera or you apply some editing to get the image into a digital format.

Spray and Pray: This phrase describes the (bad) practice of just shooting as many frames as you can, hoping (and praying) that you will get a good photo.

Strobist: This blog and website, by photographer David Hobby, is a resource for photographers that offers information about the use of small, off-camera flashes. See http://strobist.blogspot.com.

Sweet Spot of the Lens: Every lens has an aperture that creates images just a little better than the others. This is usually an aperture somewhere in the middle range. While this information might be important to some, I find it practically useless in actual practice because I tend to shoot using the aperture that gives me the look I want.

Sync Speed: The fastest shutter speed available when using a flash. The sync speed is usually 1/200 second (or 1/250 second), which is where the rear shutter doesn't start to close until the front shutter is all the way open. At higher shutter speeds, the rear shutter starts to close before the front shutter is all the way open, which means the whole sensor is not exposed at the same time and a single flash will not light up the whole frame.

Tether or Tethered: This is when you attach your camera to a computer via cable so the image or video can be seen on the monitor immediately, and then saved to the computer. Some cameras allow you to save the images to a memory card in the camera as well, while others only allow you to save the images on the computer when the camera is tethered.

Vibration Reduction / Optical Stabilization: This technology is incorporated into lenses and camera bodies to help reduce camera shake, especially when handholding the camera at slower shutter speeds.

Wide Open: This refers to taking photos at the widest possible aperture available with the lens on your camera.

LIGHT MODIFIERS:

There are many different light modifiers available to help get you the light you want.

Diffusers: Any semi-opaque material you can put between the light source and the subject.

Gels: These colored pieces of acetate go over the front of the flash or studio light to change the color of the light.

Grids: A grid is a collection of tubes that creates a controlled area of light. The amount and size of the tubes dictate how much light will fall on your subject.

Snoot: This device looks like a tube. It fits over the head of the flash to control the amount of light that spills out onto your subject. Snoots create a more focused area of light.

Softbox: This is a box made out of opaque material that fits over a light and routes it out in one direction. The light is softened by a diffusion material that covers the front of the box. Softboxes come in a wide variety of sizes for both small flashes and larger studio lights.

Umbrellas: There are two different types of lighting umbrellas to choose from. Translucent umbrellas are mostly white and semitransparent, and are often called "shoot-through" umbrellas because they go between the light source (flash or strobe) and the subject. "Bounce" umbrellas are lined with a reflective surface. The flash is fired into the umbrella and the light bounces around inside of it before it comes back out to illuminate the subject.

MEMORY CARDS:

There are a variety of memory cards available for your camera. I use the best memory cards I can find because they store my photos until the images are safely backed up on the computer.

CF: CF is short for Compact Flash, which is a memory card form factor. This form factor is on the decline, and is being replaced by smaller, faster memory cards like the XQD, CFast, SD, and MicroSD card formats. The XQD and CFast cards are the newer versions of the Compact Flash card; I believe they will replace the CF cards in the next few years.

CFast: This is a newer card technology based on the older CompactFlash cards. It's really fast, but like the XQD card, it is not compatible with the CF cards.

MicroSD: These are the tiny memory cards mainly used in GoPros, drones, and compact cameras. The MicroSD card is basically a really small SD card. Many of them come with an adapter that allows the card to be read like a regular SD card.

SD: The SD or Secure Digital memory card has been around for quite a while and comes in a staggering array of sizes and speeds. It can be really confusing to try to make sense of all the numbers. Let's start with the different types of SD cards: SD, SDHC, and SDXC. The difference is the capacity of the card. SDHC (Secure Digital High Capacity) cards have more than 2GB and less than 32GB. The SDXC (Secure Digital eXtra Capacity) cards have more than 32GB. All three of these SD cards are the same form factor and will fit in a regular SD slot. The issue arises when trying to use a newer card in an older device. If your camera is relatively new, this won't be an issue; but if you are using an older camera, you'll need to check the camera manual to see if the memory card slot is fully compatible. No point in buying a huge SDXC card if the camera only supports the SD and SDHC cards.

XQD: This is a memory card format introduced by Sony in 2012. I started using the XQD card with the Nikon D4. It is faster and smaller than the CF cards. I really love this memory card.

INDEX